December 1972

Many thanks for your
kindness and help —

Evelyn & Dick
Wagner

WITNESS TO NATURE

ALFRED EISENSTAEDT

A Studio Book

WITNESS TO NATURE

The Viking Press *New York*

ACKNOWLEDGMENTS

I would like to express my sincere appreciation to the staff of The Viking Press for their valuable assistance, particularly to Mary Kopecky, Marylou Sandbach, Nicolas Ducrot, and Cornelia Hice, and to Bryan Holme, Director of Studio Books.

First published in 1971 by The Viking Press, Inc.
625 Madison Avenue, New York, N.Y. 10022

Published simultaneously in Canada by
The Macmillan Company of Canada Limited

SBN 670-77685-8

Library of Congress catalog card number: 71-155658

Typography by Graphic Arts Composition

Printed and bound in Belgium by J. H. Masui Associates

CONTENTS

INTRODUCTION 9

I BIRDS AND ANIMALS 12

II LANDSCAPES AND FLOWERS 39

III FORESTS, FIELDS, AND PONDS 75

IV PATTERNS AND TEXTURES 99

V SPECIAL EFFECTS 123

To Kathy

Photograph of the author by Kathy Eisenstaedt

INTRODUCTION

Although I have always been best known as a photo-journalist, nothing has brought me greater pleasure than photographing nature, not only as a form of relaxation, but also as a means of gaining a greater understanding of the world we live in and the environment we share with animals and birds.

When my publisher asked me to share my views and experiences with other nature-lovers, I hesitated at the thought, for I am a photographer, not a writer. And even after I had begun to think of accepting this challenge I wondered if I had anything to contribute to the already vast store of literature on animal and plant life and the quantities of excellent photographic and illustrated books that have been published on every aspect of nature in every part of the globe.

What finally persuaded me to embark on this project was a realization that there are millions of people who love nature and are interested in photography but are not getting as much enjoyment as they might from combining these two interests. When I considered the wonderful effects that can be obtained with the simplest of means, and the satisfaction that lies in taking good photographs of nature, the focus for my new book suddenly became clear.

It is an interesting fact that although ten people might set out to photograph the same scene or object with the same camera and film, each of the ten would come back with a different record, with his own individual interpretation of the subject. The more you work with photography, the more you become aware that every serious photog-

rapher's work bears a stamp of its own that makes it recognizably his. The differences may not be as great as those you would find in paintings by Monet, Picasso, and Andrew Wyeth, but the eye of the photographer, like that of the painter, can be as creative as it is subjective.

One might then ask, can one photographer learn anything from another without becoming imitative? I believe he can. Not only is it impossible for him to duplicate the effect of another man's photograph, it is even impossible for the same photographer to do precisely the same thing twice. But by comparing notes on problems and solutions, one can always learn from the experiences of others and be inspired to try out new ideas of one's own. However, I know no magical tricks that will work for everybody. I can only say what I have done myself in certain situations. This may be helpful to others who are facing similar problems, although I would never suggest that my way of doing things should be copied by someone else. A photographer's best pictures are those that represent his own individual experience and point of view.

People continually ask me what kind of camera to use, what films, what filters, what exposures, what lenses. They seem to think that buying a lot of special equipment will automatically turn them into great photographers. Actually, of course, the photographer's greatest asset is his own imagination, and his most valuable piece of equipment is his own eye, his own ability to observe the world around him and perceive its potentialities.

I happen to use 35-mm. cameras. I started to use them years ago because I found this type of camera very handy to use for taking pictures of news events quickly and unobtrusively. I have continued to use 35-mm. cameras because I know them well and feel comfortable with them. With the help of different lenses, I can use the same camera to take pictures of almost anything. Other photographers use other types of cameras. The important thing is to get to know the particular camera you have so well that you know exactly what to expect from it, and it gradually becomes almost an extension of your own eye and hand.

Countless books have been written about color photography. Each color film has its own special way of "seeing" color, and the over-all effect of each one is different. I use Kodachrome and Ektachrome films for nature photography. Using the same films consistently leaves me free to concentrate on the subject rather than thinking about speeds and exposure settings all the time.

Years ago, photography books used to have long lists of data telling what aperture and film speed were used for every picture, but this information means very little today, when nearly everyone carries a separate exposure meter or has one within the camera itself. Even if one does not have a meter, the instructions that come with every roll of color film are a more reliable guide than someone else's photographs. No two photographic situations are ever exactly the same, especially outdoors, where changes in the time of day and the weather can completely change the mood of a scene in seconds. The only way to learn about exposures is to keep practicing with the films you like best.

Filters are another subject that always comes up in my conversations with amateur photographers. Everyone seems to think that if he can just find the right filter, all his problems will be solved. I have often seen groups of amateur photographers, all photographing the same scene, using filters in every color of the rainbow, while I was using none. There was a time when I used filters a lot, but color films have been greatly improved in recent years and need less correction. Also, my own tastes have changed

and will change again. Today I use filters when I want to create an unusual effect or to reduce glare when the light is too bright, but not for everything. There are hundreds of filters available: some simply intensify reality; others produce results that are completely unreal but pictorially fascinating. Each kind of color film reacts differently to these filters. The choice of filters a photographer makes depends on how he feels about a scene or subject, and what he wants to say about it in his photograph.

There are lenses today for every conceivable purpose. As I am interested in photographing both landscapes and very small details of nature, I use telephoto, close-up, and wide-angle lenses. And I love to experiment with new ones. Changing lenses makes it possible to try different ways of photographing the same scene and to create many impressions of the same subject, but many of my best pictures have been taken with very simple equipment. Ultimately, it is the idea a photograph expresses that makes it interesting, not the technique.

On the following pages are many pictures of nature which I consider to be among the best I have taken. Included with them are notes explaining how they were done. Some were taken when I was on assignment in distant places, but many are of quite ordinary things encountered during a stroll along the shore, in the woods, or in a park. One never has to go far to find an idea.

I

BIRDS AND ANIMALS

Taking pictures of wildlife is the most delightful—and sometimes the most exasperating—experience a photographer can have. You never know what a bird or an animal will do next, and I have found that the most important element in my equipment is not an expensive camera or a unique lens but patience, patience, patience.

If you don't know how to stand knee-deep in water for hours, or sit broiling in the sunshine while the mosquitoes buzz around your head, remaining absolutely motionless yet relaxed and alert, you are finished before you start. It's a question of temperament more than technique, for you have to be equally ready to control your own reactions and keep calm when exciting things are happening, and to remain happy when nothing at all happens. If you really love nature as I do, you are not even aware that time is passing, or that your feet are soaking wet, or that all your muscles are aching.

Should the sun begin to go down while I am still waiting for a snail to come out of its shell or for a butterfly to alight on a flower, I never feel my time has been wasted, for I have always enjoyed every minute I have spent observing nature, and I have learned something new each time.

The most difficult thing I have had to learn to do—and I think I have at last succeeded—is to make myself as inconspicuous as possible. This is really hard. It takes every ounce of self-control I possess to keep from acting impulsively when beautiful pictures start coming to life around me. It would be nice to be invisible, but as this cannot be, I try my best to blend gently into the background so that the animal or bird I want to photograph accepts me as part of the landscape. One false move—and that usually means any movement at all—and I have lost my chance.

12

Through years of experience, I have trained myself to keep absolutely calm and quiet, no matter what is happening, and to move with the slowest of slow motions, raising my camera to my eye one cautious fraction of an inch at a time, freezing completely for a moment or two if it seems my subject is becoming aware of my presence.

One of the advantages of a camera with a quiet shutter is that it enables the photographer to take pictures of people and wildlife without attracting their attention. Birds and animals have very acute hearing, and the slightest sound will cause them to take flight immediately.

If the situation is one where I can work from a fixed position—a place where I know that I can expect some wildlife to appear—I find it helpful to use a tripod, select the background, and set my exposures in advance. Then, when my subject moves into view, I am ready to release the shutter with the absolute minimum of time and motion. And should it turn out that I must wait for a long time, or shoot from an awkward position, I can sit on a log or a stool and let the tripod do a lot of the work for me.

Although my outward motions are calm, my inner response must be swift and immediate. Through constant practice, I have learned to release the shutter firmly and automatically in an instantaneous short-cut reaction that seems to go directly from the eye to the finger, by-passing any delaying conferences with my brain.

Whenever I am out on a nature assignment, as opposed to just taking pictures for my own pleasure, I usually take along a selection of telephoto lenses, as well as shorter lenses, and a tripod. Although many outdoor wildlife shots can be taken at 1/250 second, I never know just what the light conditions are going to be, and trying to hand-hold a camera with a heavy telephoto lens is hopeless. Sometimes, when the light is dim and the lens a very long one, I use two tripods, one to steady the camera and the other to give extra support to the lens.

After taking all these elaborate precautions, I have often found that my best pictures were not the ones for which I had set up my equipment, but the chance photograph I was able to get, while waiting for my intended subject, of some other little creature that suddenly appeared from another direction. I have developed the habit of taking along at least one extra camera, set and ready for action, hand-held, so that I won't miss anything by having to stop and readjust the camera. This helps to keep me relaxed and alert during the tension of waiting for the main subject to make an entrance.

NOTES ON PLATES 1–19

1. This picture of a rhesus monkey was taken in India, where I had gone on an assignment to gather material on the behavior of monkeys. When I arrived at Fort Tukalabad, about twenty-five or thirty miles from New Delhi, passers-by could not believe that I had actually come all the way from the United States just to take pictures of monkeys. The animals were so numerous there —moving about in groups of twenty-five or

thirty—that thousands were being caught annually and shipped to the United States. One of the first things I was told was never to look a monkey in the eye. Monkeys seem to take this as a challenge, grow increasingly angry, and then begin to howl. I don't think any other animal reacts this way.

The rhesus was in an open field alone. His brothers and sisters were still napping in the trees. Like most monkeys, he was restless, and in photographing him I found myself constantly having to refocus. At the same time I was obliged to keep dodging a relentless swarm of bees, and at one moment I had to beat a hasty retreat, leaving my equipment behind. It was all a good deal less peaceful and pastoral than you might imagine from looking at the photograph.

2. A trio of polar bears in the San Diego Zoo. It was a rather warm day, and the bears were lounging around in lazy attitudes—something I probably ought to do more often myself, but I'm too restless. The slow motion of the bears made this amusing composition possible.

3 and 4. Two birds photographed on Indefatigable, one of the many Galápagos Islands, not far from Academy Bay. The islands lie about six hundred miles west of Ecuador, and I was taken there in an ancient Ecuadorian government plane, so the trip took only six or eight hours, instead of the four days it would have taken to go by boat. The plane landed on an abandoned World War II airstrip on Jersey Island, and from there it was another five hours by boat to Indefatigable. I was quartered in a primitive hut, which I shared with hordes of insects, including some of the largest spiders I have ever seen, which I hope never to encounter again. They were scuttling about the floor and walls and dropping from the ceiling. It was the time of the *garua*, the rainy season, which in the Galápagos takes the form of mists and drizzle rather than heavy rain. I had had no advance notice of the weather conditions, so it was not until I actually got there that I realized there would be no possibility of getting any pictures in full sunlight. It took some time to get used to the terrain, which was all rough lava and brimstone.

I was surprised at first by the absolute fearlessness of the Darwin finches, which seemed completely undisturbed by my presence. I was thus able to photograph them at close range with a hand-held camera and short telephoto lenses. The island is so sparsely inhabited that the birds have not learned to fear people. The little bird at the right is seated on a chunk of lava in the highlands. The slopes were overgrown with vines, so that we could not see the holes underfoot. It drizzled constantly, and I was soaking wet, but finding these beautiful little birds made the effort, and the discomfort, more than worth while.

5. Taking pictures of birds is always difficult, and photographing these pelicans in flight proved no exception. I had to be alert every second, ready to react quickly to their unpredictable movements. Using a rangefinder camera and a wide-angle lens, I released the shutter just as the pelican with outstretched wings came in above the others, forming this exciting pattern.

6. An egret taking off from its nest in Florida on a warm August day. I used a 400-mm. telephoto lens and made an exposure of 1/250 second at f/5.6

7. Baby egrets waiting for their parents to bring food back to their nest on an island wildlife refuge near New Iberia, Louisiana. Alligators roam the murky waters of the swamp, ready to snap up any small birds that fall from their nests. It was a warm, muggy day without bright sun, so I was able to get the details of the birds' downy plumage without any distracting glare.

8. This strange long-necked bird, its elongated form reminiscent of the roadrunner of the western United States, was found among the lava rocks of James Island in the Galápagos. I was pleased that the details of the dull black rocks came out so distinctly. Here again the damp weather and hazy sunlight were assets. The light layer of moisture on the boulders heightened all the subtle variations in the color as well as the details of the bird itself. The old-fashioned idea that you have to have very bright, sunny weather for color photography is no longer true.

14

9, 10, 11. Three pictures taken in Kenya. The appealing family of elephants (Plate 9) came into view while I was standing on the roof of the Treetop Hotel near Nyeri. The hotel's location is the most perfect one imaginable for wildlife photography. In the evening spotlights go on, illuminating the fantastic parade of elephants, water buffalo, rhinos, antelopes, and other species. The giraffes (Plate 10) and the lion (Plate 11) were taken from the window of a car in Nairobi National Park. The lion was surrounded by five others, and with a 300-mm. lens on the camera I leaned far out of the automobile to focus on its majestic face. The lions in the park, protected by law, are quite tame, and you can come close to them as long as you stay in your car. Any closer fraternization is wisely discouraged by the park authorities. Quite often ten or twelve cars will surround the same lion, with everybody trying to get a good picture.

12. Lake Nakuru in Kenya, famous as a wildlife refuge, is said to harbor more than a million flamingos as well as innumerable pelicans and other waterfowl. To get this picture I had to put on waders and walk across a shoreline thick with foul-smelling guano. The flamingos are shy, but not as shy as most wild geese and ducks. My shutter was set at 1/500 second and I was using a 105-mm. lens. It was a very warm, hazy day, but I avoided the use of filters in order to preserve the atmosphere exactly as it appeared to the eye. (Warming-up filters usually produce unduly pinkish effects, which can be pretty but artificial, and should therefore be used with caution.) There is, of course, no way to direct wild birds into a pleasing pattern. I just had to wait patiently for hours until something suddenly startled the flamingos into flight at the right angle for my picture.

13. Quite by accident I found this little black pond early one morning when I had stopped near a small church to look at the headstones. I was completely captivated by the scene and wished that there were a few swans to add a final touch of beauty. Then, by great good luck, I saw some in the distance. I got my camera ready, focused my 200-mm. lens, and prayed that they would come my way. After about an hour, the swans drifted serenely out into the middle of the pond without making so much as a ripple. This is one of my favorite photographs. Against the backdrop of deep shade the swans and their reflections appear to be suspended in the black water like a vision seen in a dream.

14. Compared to other waterfowl, this Australian black swan was not shy. It was about noon, with the sun high overhead, when I took this picture, and the strong light enabled me to capture the graceful detail of the swan's neck and elegant plumage. On a dull day the image would have been little more than a black blob.

15 and 16. Luckily Puna, the black Persian cat in Plate 15, was in a relatively lethargic mood the day I photographed it in a friend's home. At every moment there was the possibility that the cat would get fed up with watching the camera and find some more active form of amusement, but Puna remained quiet and this regal portrait was made without much difficulty. Quite the opposite occurred with the picture of the white cat in Plate 16. I was in Orvieto, Italy, and, as I always do when visiting a new place, I managed to find time to explore the town on foot. In this narrow courtyard, no one was there and nothing was moving, but I waited about forty minutes, my camera ready, hoping that perhaps some passer-by might appear to make the picture more interesting. Nothing happened, but I decided to wait a few more minutes before giving up, and the charm worked. As my deadline ran out, the cat appeared around the corner at the left. Without noticing me, it jumped into the sunlight and suddenly ran back again. I got my picture at the moment the cat moved back into the shade. Luck is an important element in getting pictures like this—luck and the habit of being ready for the unexpected. The cat crossed the pavement in just the right place, and I managed to get the picture at just the right moment. A fraction of a second sooner or later would have made all the difference in the world.

17. Good animal pictures are to be found

in every corner of the world. I was in India when I got a cable to go to France on a hopelessly open assignment: "Photograph Paris." Where do you begin? What can you do that hasn't been done by every photographer and painter who has ever been there? Well, you just go out and get started, so I picked up my camera and began to walk, and on a side street near Montmartre I found this little mongrel beneath a concierge's window, so weighted down with a chain that the poor creature could hardly hold its head up. The unhappy dog looked as though it would have been unable to run away even if it had been held by only a thread. The cold, monotonous light of the narrow street seemed to symbolize the animal's bleak prospects.

18. I found these Brahmin cattle and hundreds of macaques scrounging for food all over the decaying Sitaram temple in Galta, near Jaipur, India. The stench was overpowering, and I had great difficulty picking a way through the animal droppings. The sunlight that brightened the scene and made it possible to see clearly the rich decoration of the old temple also served to emphasize the poverty of its present inhabitants.

19. For many years, as I traveled to various parts of the United States, I had dreamed of finding a scene like this one in Florida. My vision was one of horses running freely through a meadow, and this spot, with its beautiful trees and trim fences, was the perfect place for it to come true.

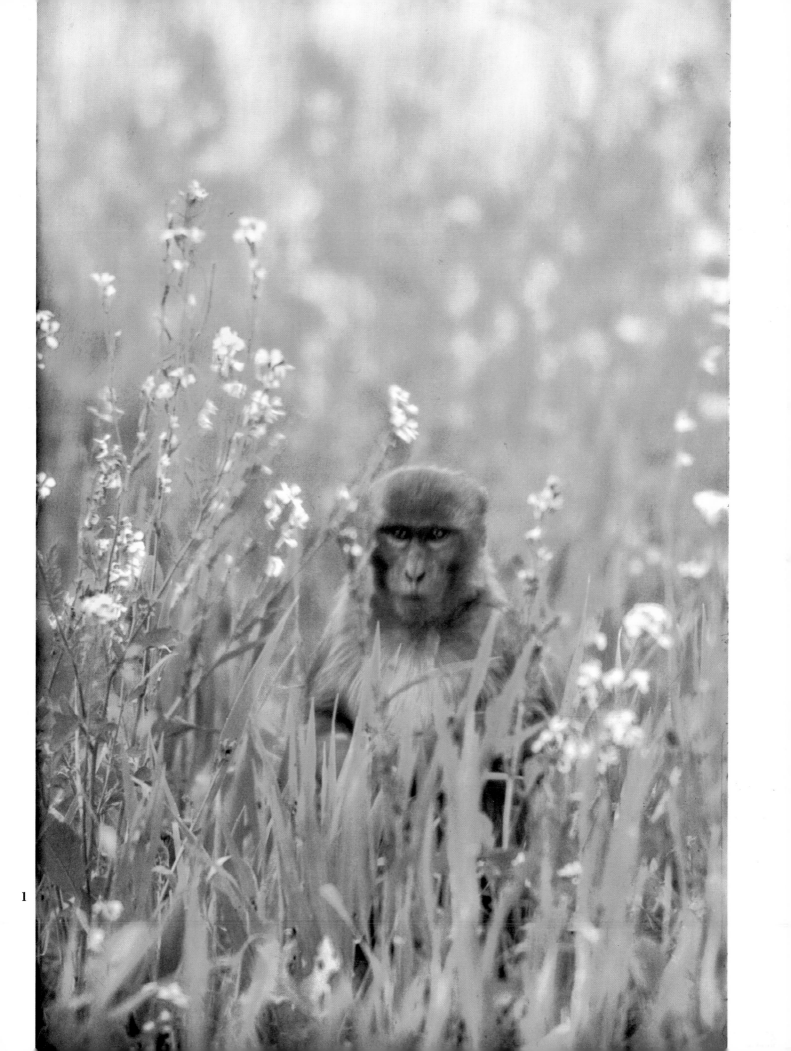

1

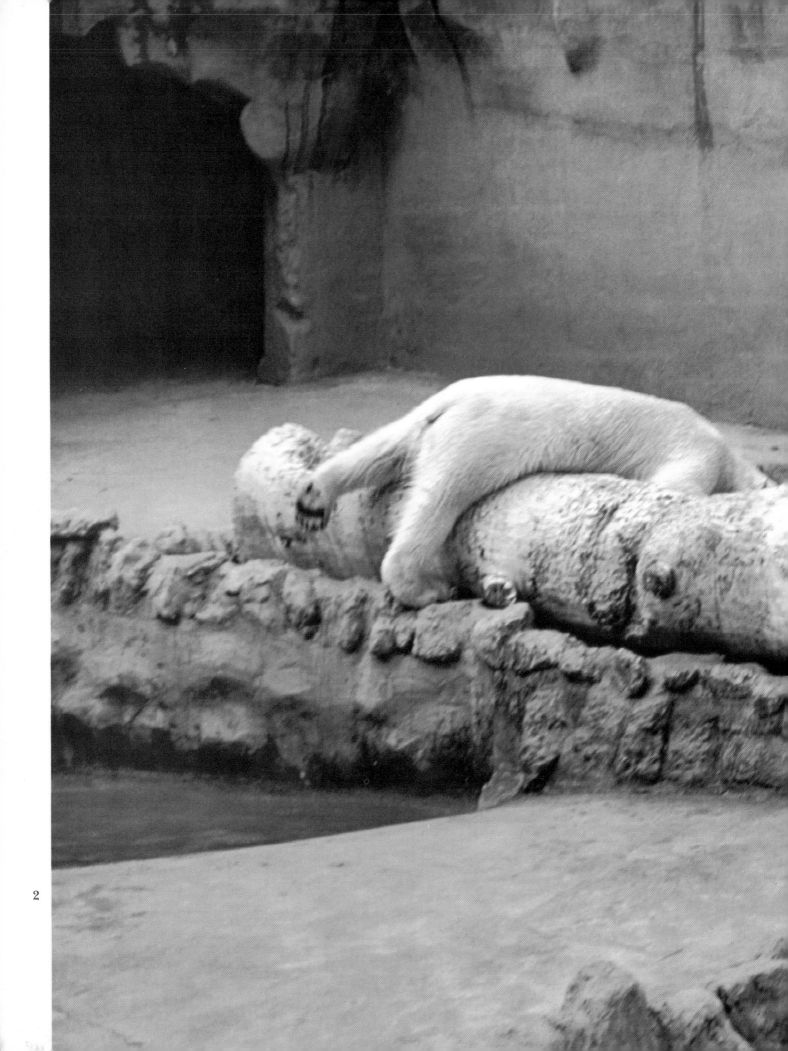

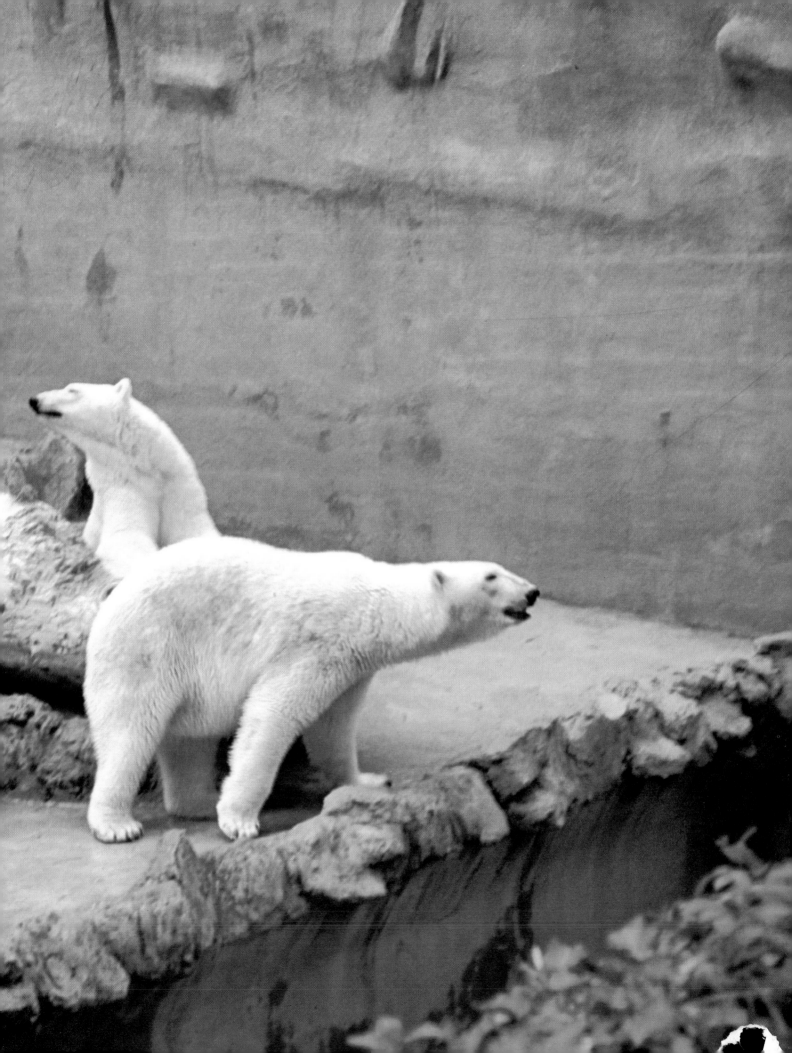

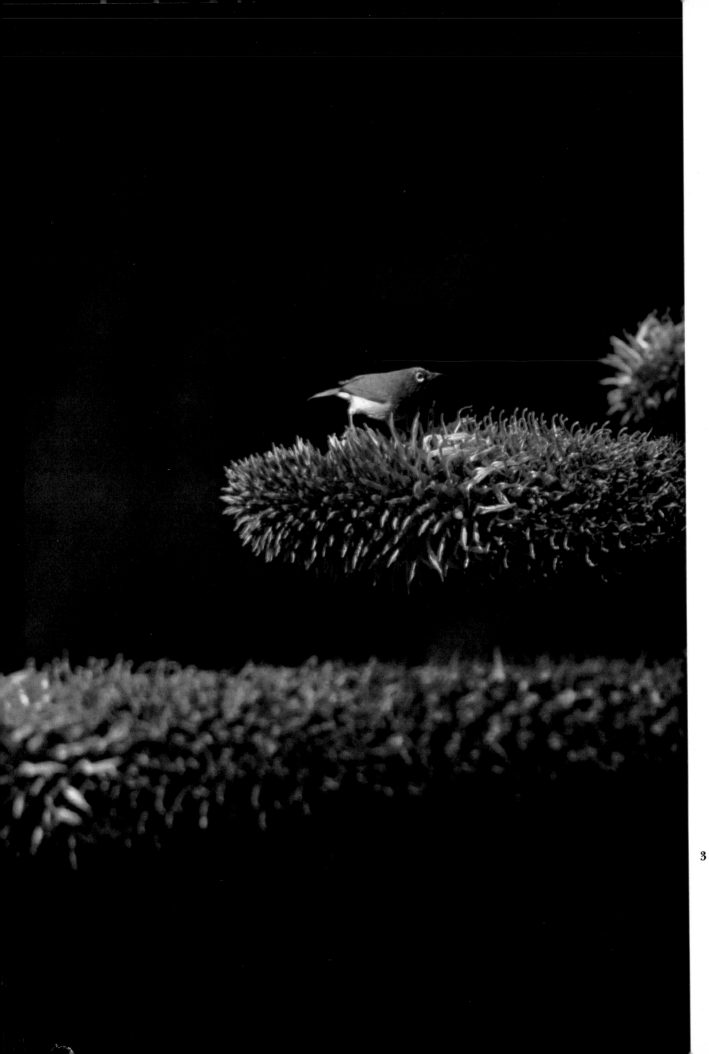

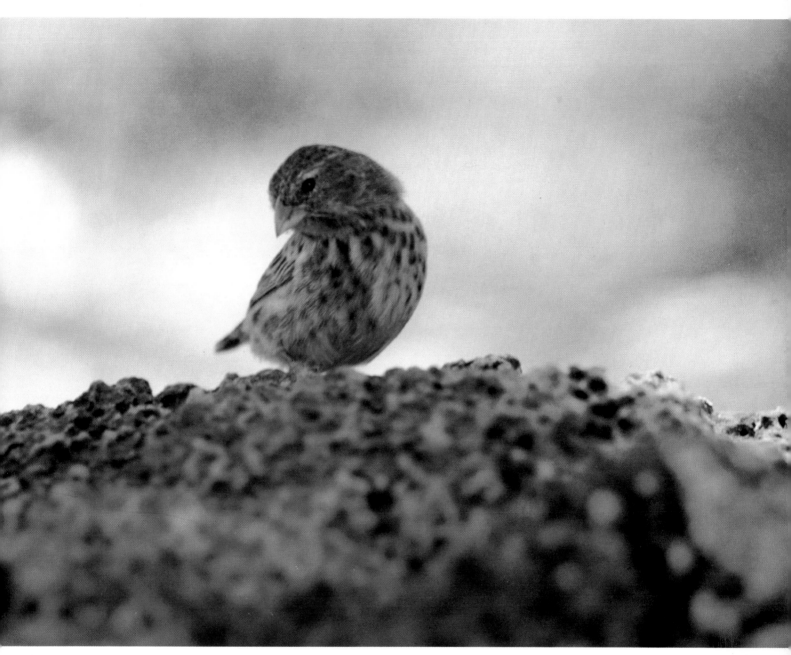

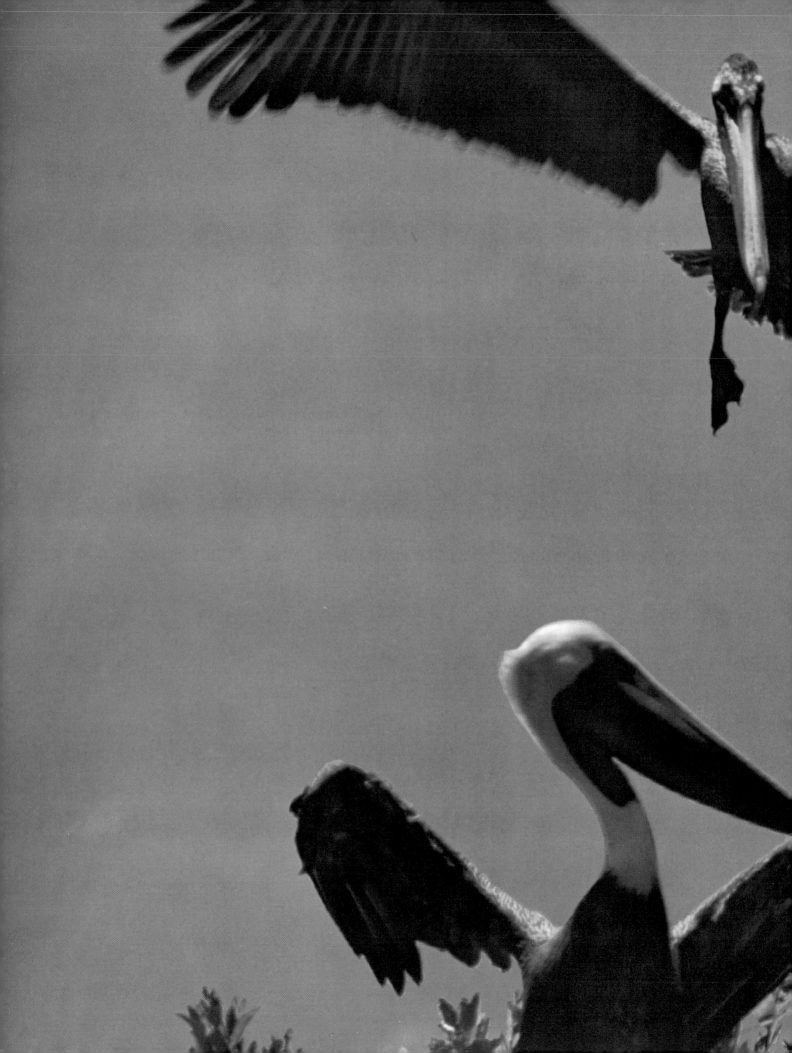

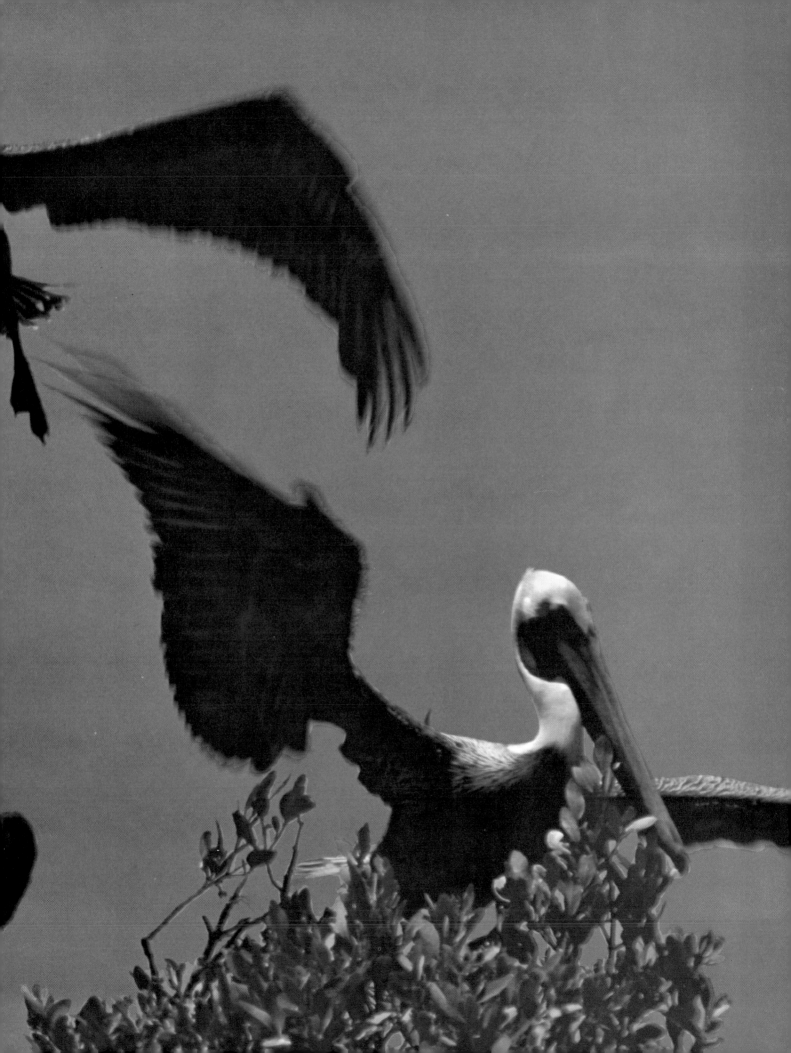

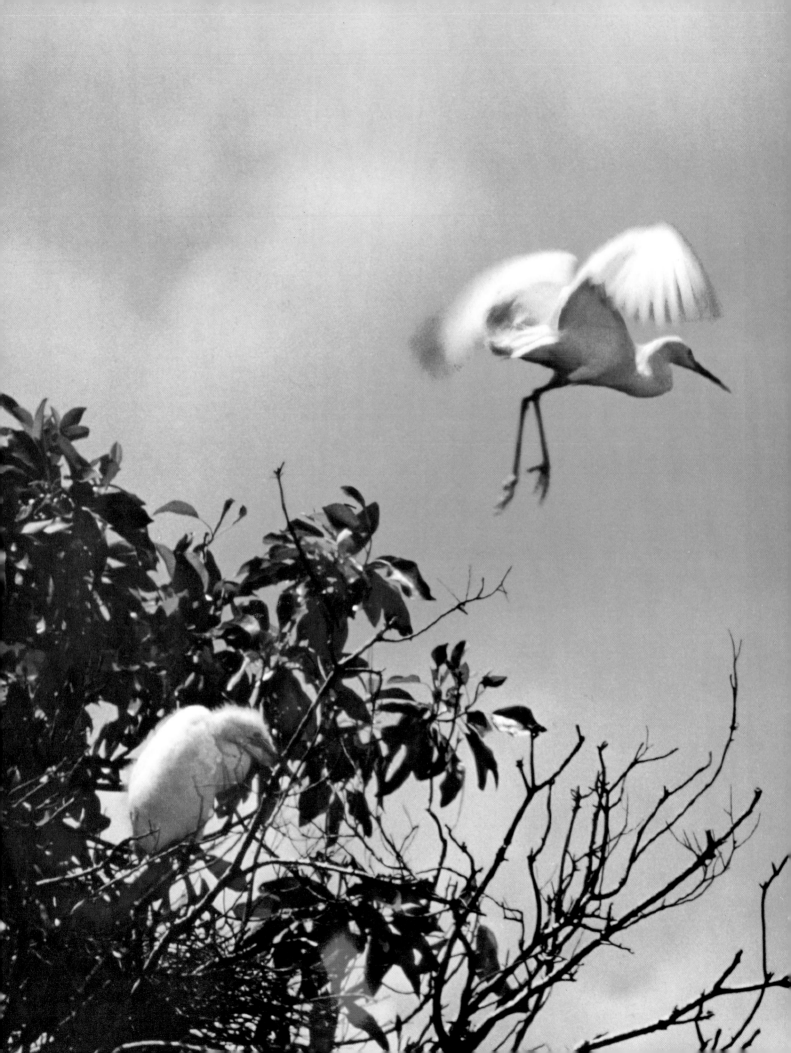

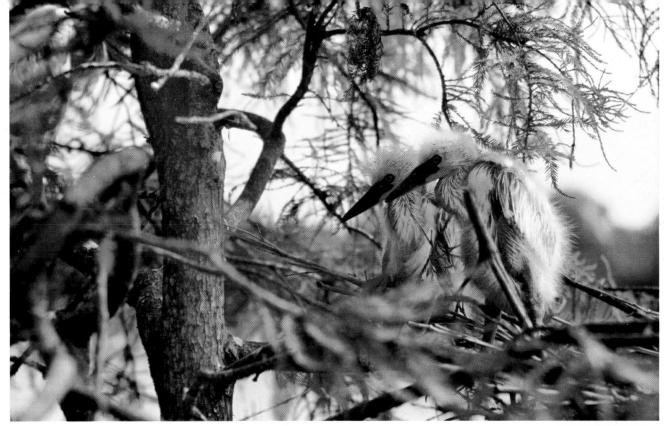

7

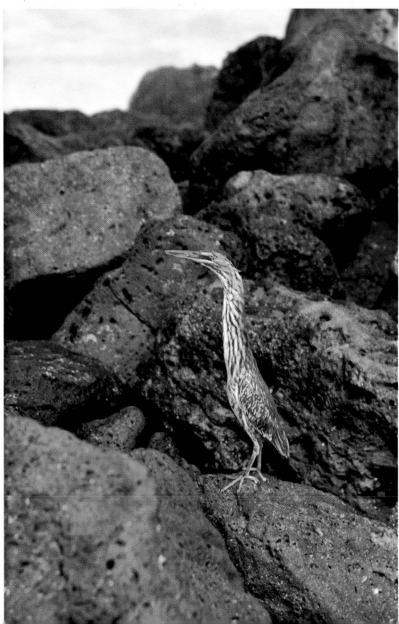

8

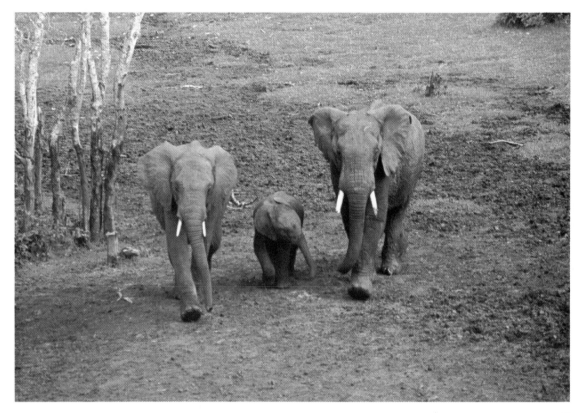

9

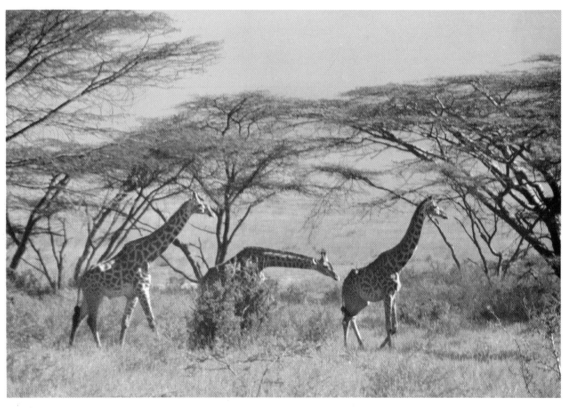

10

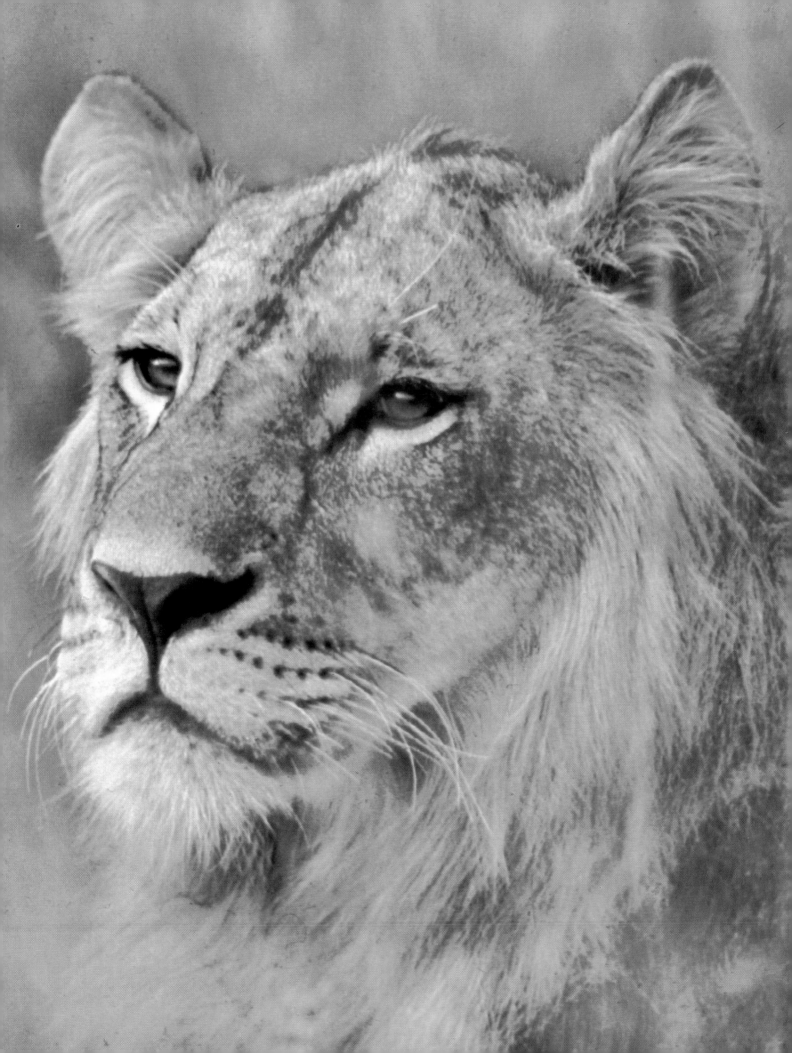

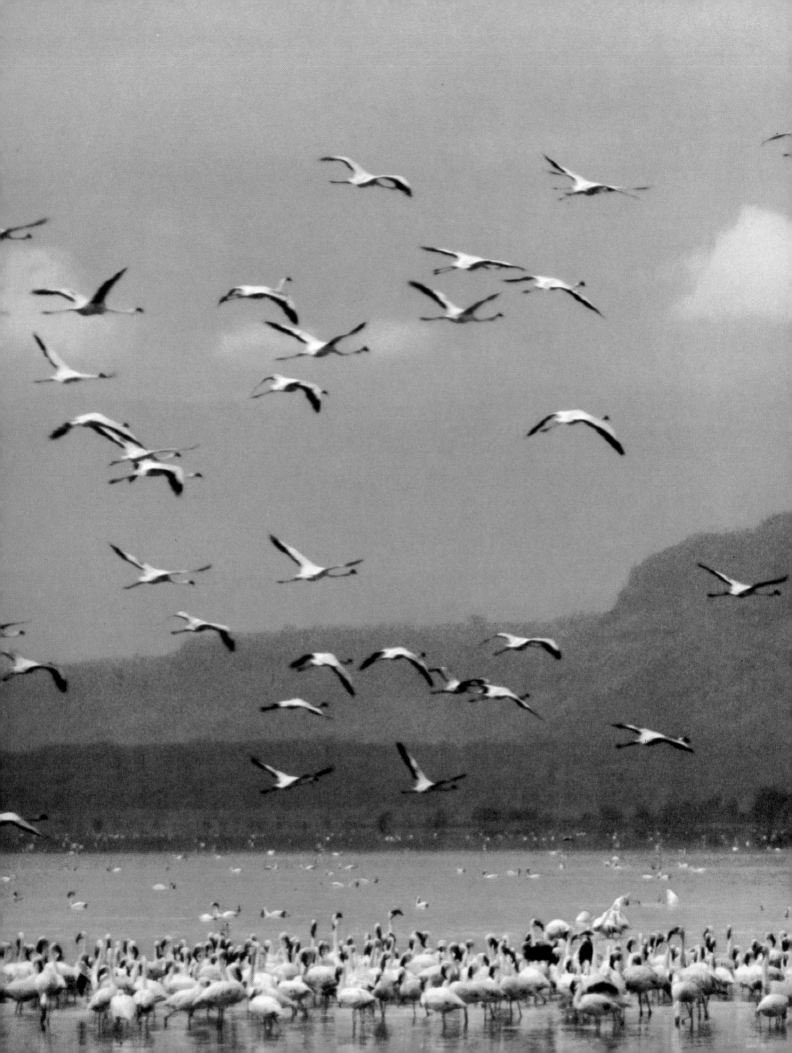

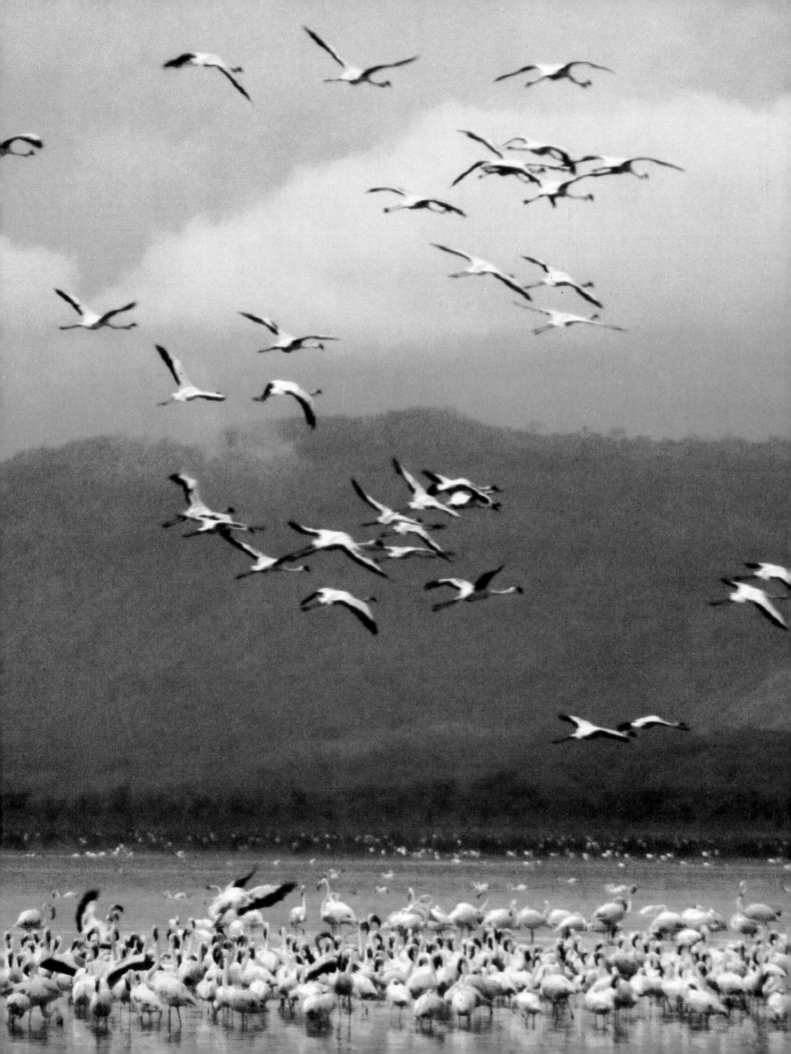

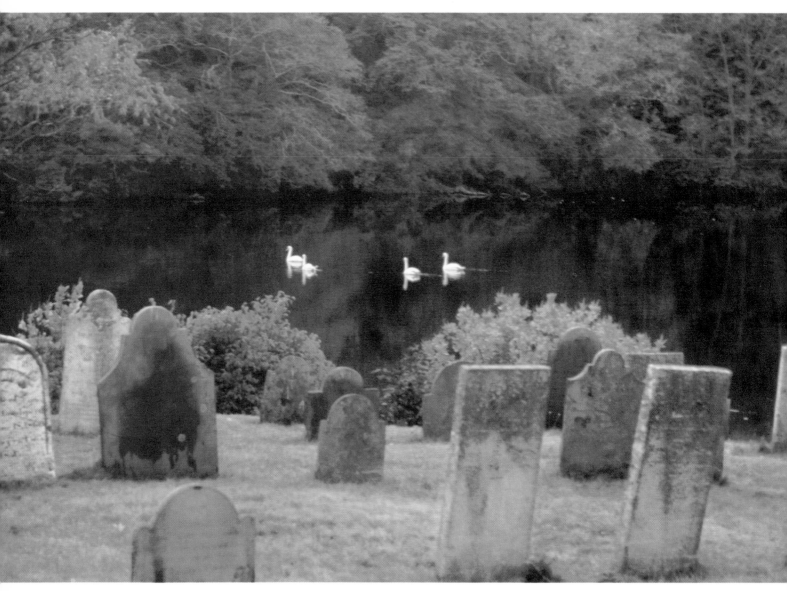

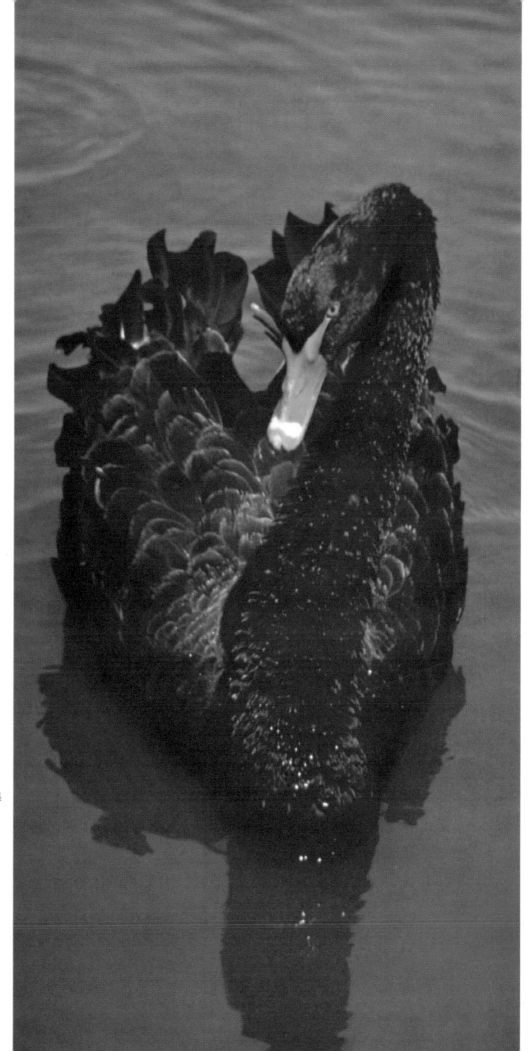

14

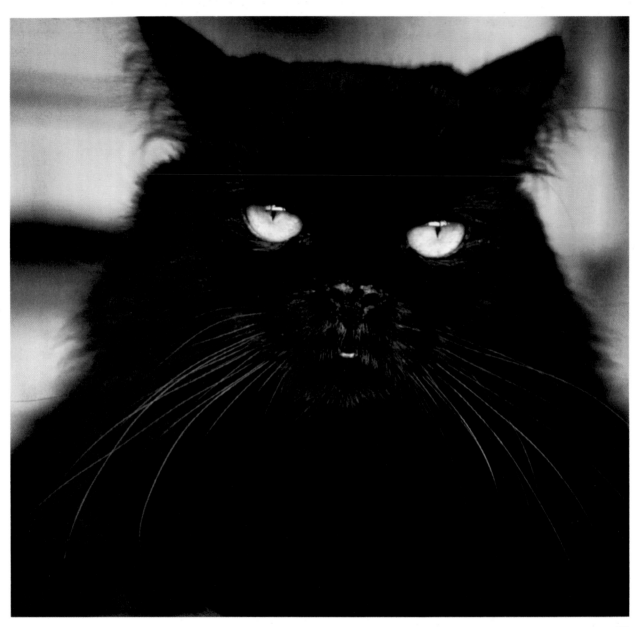

15

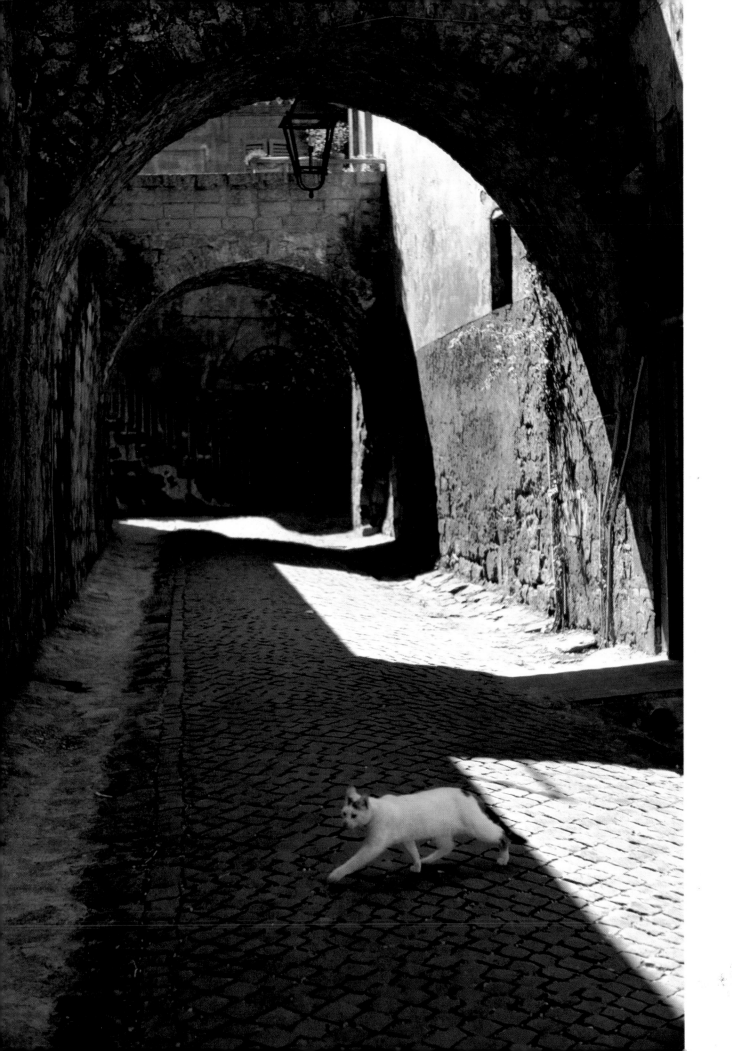

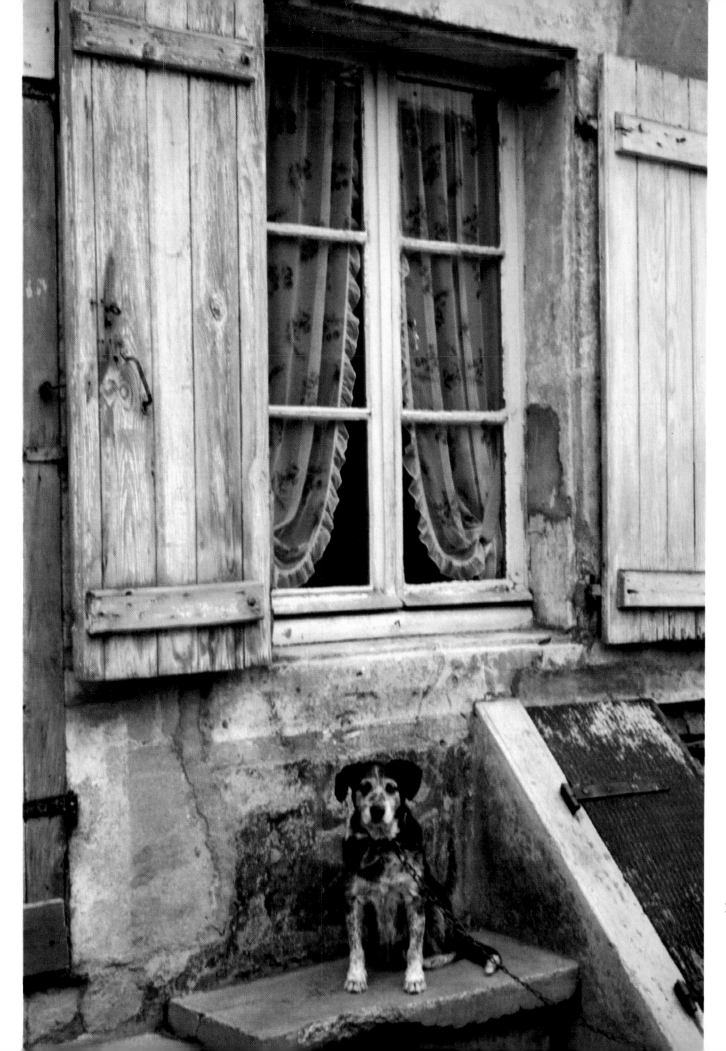

17

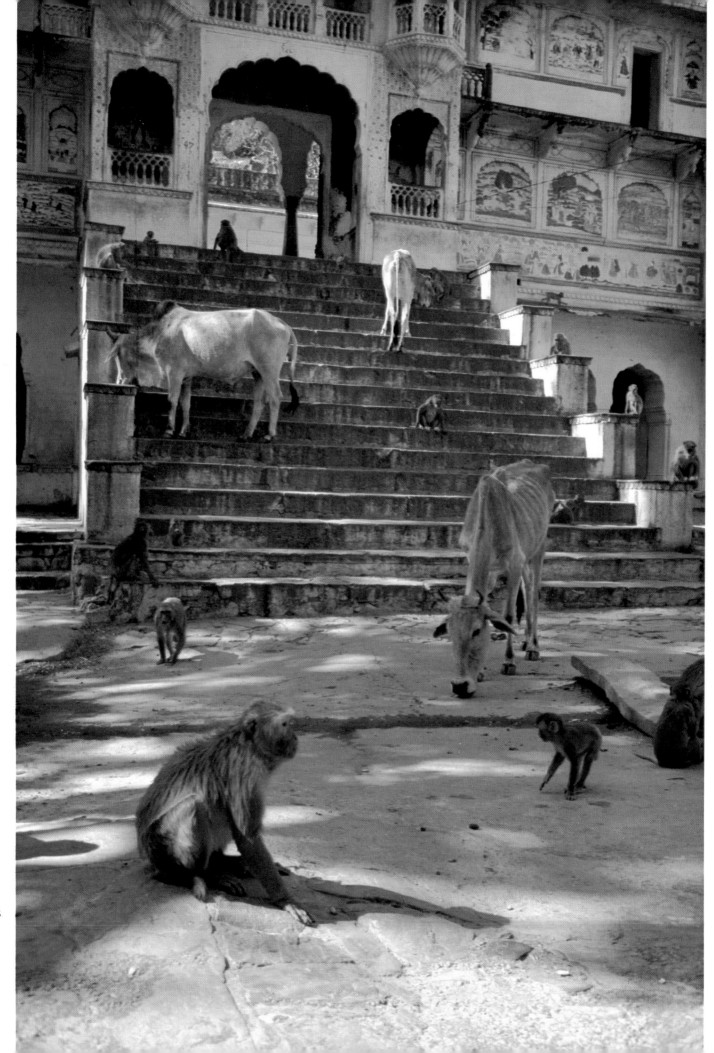

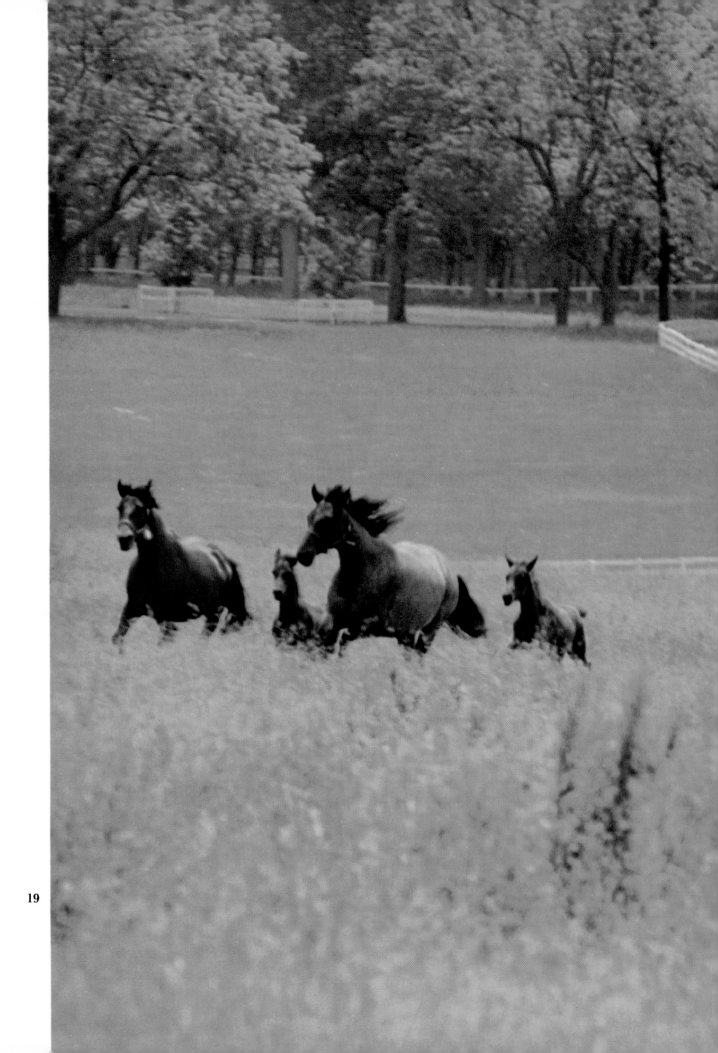

19

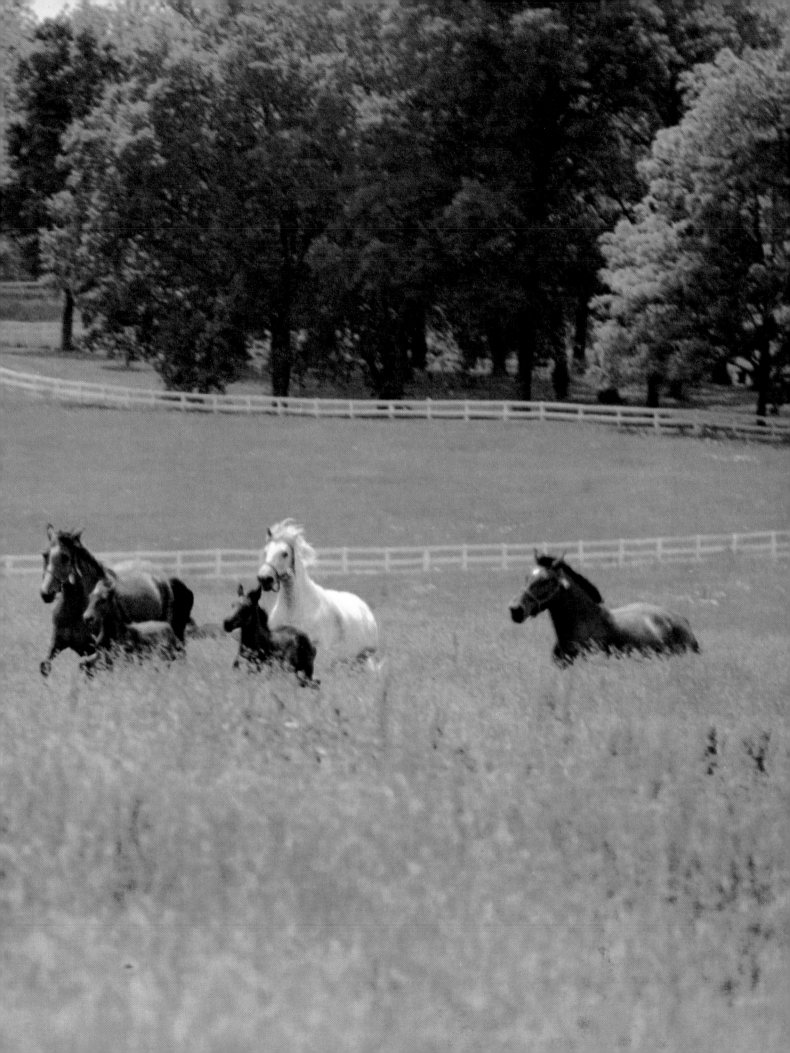

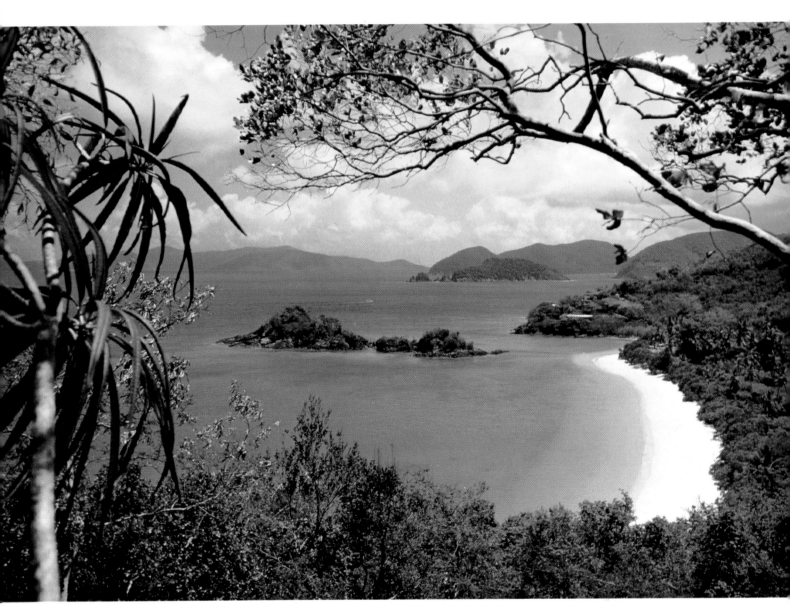

II

LANDSCAPES AND FLOWERS

Landscapes and flowers represent two extremes in photography—the broad view and the minute detail—and frequently call for quite different equipment. Although, throughout my career, I have consistently used range-finder and single-lens reflex 35-mm. cameras, and try to keep all incidental gadgets to a bare minimum, like any other photographer who works with more than one kind of subject, I find I have need of a variety of lenses. Whereas most of the landscapes in this book were taken with an ordinary wide-angle lens and a hand-held camera, some of the close-ups of flowers and insects, such as those of orchids, had to be done with lenses attached to extension tubes.

Many of my favorite nature photographs were taken in odd moments of leisure while I was on an assignment in some strange corner of the world. On every trip to a new country or city, one that I have never seen before, I manage to find a little time to go wandering about by myself, carrying just my camera and a few extra rolls of film, looking for the unexpected. And seldom am I disappointed.

Taking pictures of landscapes, along with taking snapshots of one's family, friends, and pets, is probably the oldest photographic pastime in the world. As a result, it is always difficult for a photographer to find a new approach. It's hard to escape the cliché effect. When I arrive in new places, I find myself automatically browsing through the postcards in the corner drugstore or at the airport newsstand, making a mental list of places to see, and perhaps to avoid. But there are some scenes—such as the view of Caneel Bay in Plate 20—that I just cannot resist, even if they do look like something that has been done a thousand times before.

Even though a scene may be familiar, I have the satisfaction of knowing that my picture is unlikely to be exactly like anyone else's, for, as I have said, weather and the time of day play a great part in all nature photography. What is very beautiful and romantic in the mists of morning may be completely drab and uninteresting in the middle of the afternoon, and the long shadows of sunset or the dramatic clouds of an approaching storm can turn a dull street or a flat seascape into a very exciting photograph.

Occasionally the very weather conditions that make a picture possible also create mechanical difficulties. The morning I took the snowscape in Plate 21, the bitter cold that had brought the snow was affecting my camera, so that I had to carry it under my coat. Temperatures as low as ten degrees Fahrenheit may slow down the action of the shutter. At such times, I do what I can to keep the camera warm until it is actually time to take the picture, and then listen very carefully as I press the release, mentally timing the interval until I hear the shutter close, to make sure the mechanism is reacting properly.

NOTES ON PLATES 20–46

20. View of a beach near Caneel Bay on St. John in the Virgin Islands. It was taken with a 35-mm. lens and with a polarizing filter to subdue the extreme brightness of the tropical sunlight and bring out the deep blue of the sky and the whiteness of sand and clouds.

21. I love taking snow scenes, but avoid midday, when the brilliant sunlight, devoid of shadow, tends to make the world look like a blank sheet of paper. This picture was taken on a bitter cold morning in St. Moritz, Switzerland, with my lens pointed directly into the sun to catch the halo of light coming through the ice-coated fir trees.

22. A blossoming plant photographed against the rugged highlands of Ethiopia. The overhanging clouds gave me just enough sun in the foreground to highlight the details of the flower against a darkened background.

23. This view of misty highlands was photographed near Arrochan, Scotland. The fisherman is essential to the picture; he adds a necessary touch of life to what otherwise would have been a somewhat monotonous composition. The photograph was taken as the sun was breaking through the morning mist, a crucial hair's breadth above the top of the frame, so that its rays were reflected in the sparkling stream.

24. I have taken a lot of pictures of breaking surf from a beach, using telephoto lenses, but this one was taken from the best possible place—waist-deep in the water—with a 35-mm. lens, at 1/1000 second. You have to be really in there yourself if you want to get the effect of the overwhelming impact of the ocean as it roars inward. Between pictures, I had to hold the camera high over my head to keep it from getting wet as the waves crashed.

25. These beautiful pink rhododendrons were photographed on the Craggy Mountain Plateau near Linville, North Carolina.

26. A little clump of dusty miller clinging to life on the side of a sand dune. I used a polarizing filter to bring out the modeling of the soft cumulus clouds against the deep

blue sky, for their outlines form an important part of the picture.

27. Even the simplest, most ordinary things can make an encounter with nature a pleasant experience and turn a bland landscape into an interesting photograph. I found this picture as I lay flat upon the dunes with my lens focused on the seed heads of the grasses, and the sea lapping on the shore became merely the background of an intimate nature study.

28. When I think of Cape Cod and Martha's Vineyard, it is the dunes and moors that I remember. This view was taken from a low vantage point and with a 50-mm. lens.

29. Moonlight view of Lake Superior. I was interested in the dramatic wind-twisted shapes of the trees and placed my camera so that they would be silhouetted by the moon.

30. In the dim electric illumination of this cave in Majorca, my light meter was of little use, so I had to guess the exposures for my indoor film. A 28-mm. lens gave me a broad view of the far reaches of the cave, and a tripod steadied my camera for the long exposure. The light bulbs strung across the roof of the cave produced an eerie white glow that was reproduced in a double image by the reflections in the water covering the floor.

31. The sky was completely overcast the day I came upon this haunting landscape in the Grand Tetons. The picture was taken with a 35-mm. lens and a light blue filter. Another photograph of this same scene (in Plate 51), taken from almost the same angle but with a 400-mm. lens, shows quite different results.

32. Clouds offer endless opportunities for picture-taking, and on one occasion the plane I was in was about to run into an electrical storm, so I quickly got my camera ready and, using a polarizing filter to darken the blue of the sky, recorded these lovely formations.

33. A different kind of cloud is created by the eruption of Old Faithful in Yellowstone National Park. Here the sky was already so blue it wasn't necessary to use a polarizing filter, and the great column of vapor emerging from the geyser shielded my lens from the direct rays of the sun.

34. In Norway, I came upon this small horse when it was already quite dark and raining heavily. I kept my distance with a 200-mm. telephoto lens and used a fence post to steady my hand for a short time exposure. Luckily the horse was not disturbed by my unfamiliar presence, but I was wet to the bone by the time I had my picture.

35. A carpet of flowers in a sunny meadow high in the mountains near Åndalsnes, Norway. I made two different versions of this subject, focusing at first on infinity and letting the flowers become blurred, and then concentrating on the flowers so that the outlines of the farm became hazy in the background. The version you see here is the one that most faithfully evokes the impression I had at the moment this beautiful vista first opened out before me.

36. I have always loved cosmos and for years had wanted to photograph them at the height of their bloom, but something always seemed to prevent my doing so. At last, one lovely August day, my wish was realized when I found these graceful flowers growing by the roadside.

37. These little daisy-like flowers caught my eye one dull July day in Boscastle, Cornwall, near Tintagel, the legendary birthplace of King Arthur. The minute I stopped to take a photograph, several other passers-by came over with their cameras and started to copy me. This often happens; people seem to ignore an unusual or lovely sight until someone else notices it. The flowers, sometimes called Livingston daisies, belong to the Mesembryanthemum family.

38. This little group of blue grape hyacinths had me on my knees, with my eye and my camera right down at their level. I focused my 90-mm. lens directly on the grape hyacinths and let the background blur into a hazy pastel.

41

39. Orchids are one of my favorite subjects. Through the years I have photographed thousands of rare and beautiful specimens in the greenhouses of a friend. Growing orchids is his hobby, and photographing them is mine, and it is a wonderful experience to be able to wander about among all those fantastic shapes and colors. I work with the natural light coming through the windows. Many of the pictures have to be taken with lenses attached to extension tubes. A tripod is always necessary for many of the exposures are more than a second long, with the diaphragm closed down to a minimum in order to increase the depth of field. For this orchid, a hybrid cross between a cattleya and an oncidium, I focused sharply on one blossom and let the rest fade into the background.

40 and 41. I must have passed these few roses peeking out between the palings of a picket fence many times, but one day when the sun was directly overhead I got out of the car to investigate. The blooms were already past their prime, but I could not resist taking this picture before going on my way. Photographing the garden rose in Plate 43 was a more formal matter. I used a Leicaflex with a 90-mm. lens, adjusting it very carefully to get into the heart of the blossom.

42. This dreamlike landscape, so unlike anything we see in the Western world, is a tea plantation about 6800 feet high in the mountains of Ceylon, between Pollanaruwa and Nuwara Eliya. As the morning mist rose, the trees seemed to be suspended in the air. The photograph was taken with a 35-mm. lens and a Skylight filter.

43. The reflections of the blue sky and the brilliantly colored oak leaves floating in this slow-moving stream were one of the most beautiful sights I have seen. They were photographed with a hand-held camera and 50-mm. lens plus a Skylight filter.

44. Before photographing these wild grapes, I considered whether to bring all of the tangled vine into sharp focus, or to create an over-all pictorial effect. I finally decided on the latter and used a wide aperture so that the vine would be out of focus and form a soft background. I used a 50-mm. lens, with the aperture set at f/4.5.

45 and 46. Sunsets, like sunrises, are irresistible. The light changes from minute to minute, and no two are ever the same. The one in Plate 45 was taken one late August evening. A seagull was sitting far out on the end of a jetty, and I used a 400-mm. lens and telextender in order to bring it close enough to be an important part of the picture. A few nights later I got out my telextender again, this time with a 500-mm. lens, with two tripods to steady it, to take a picture of the moon (Plate 46). It was impossible to use a meter, so I had to guess the exposure.

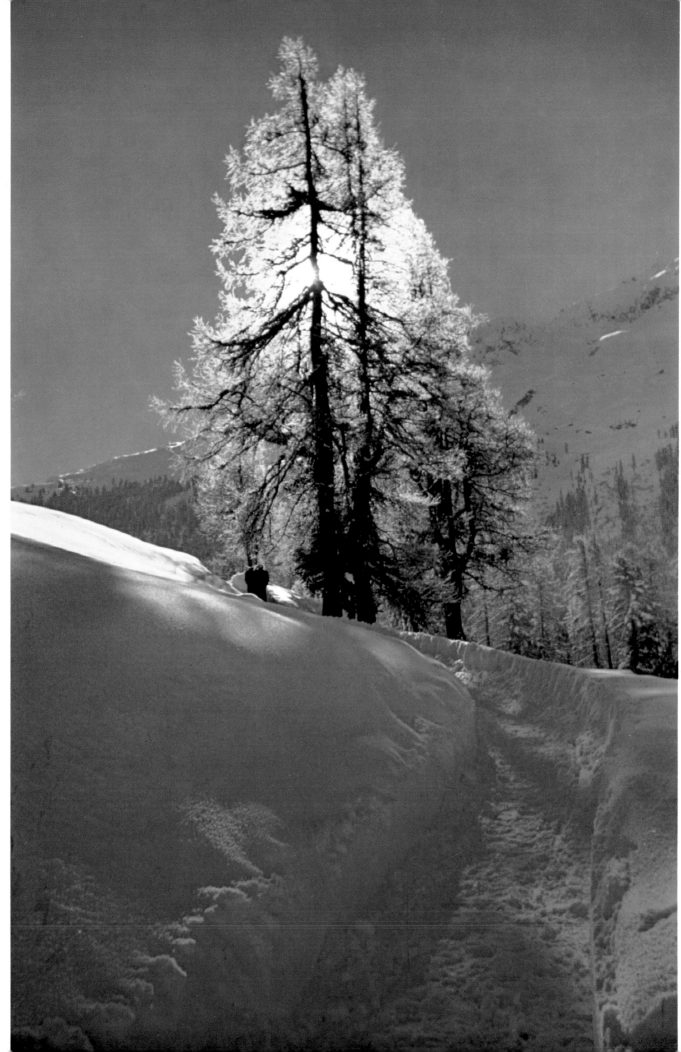

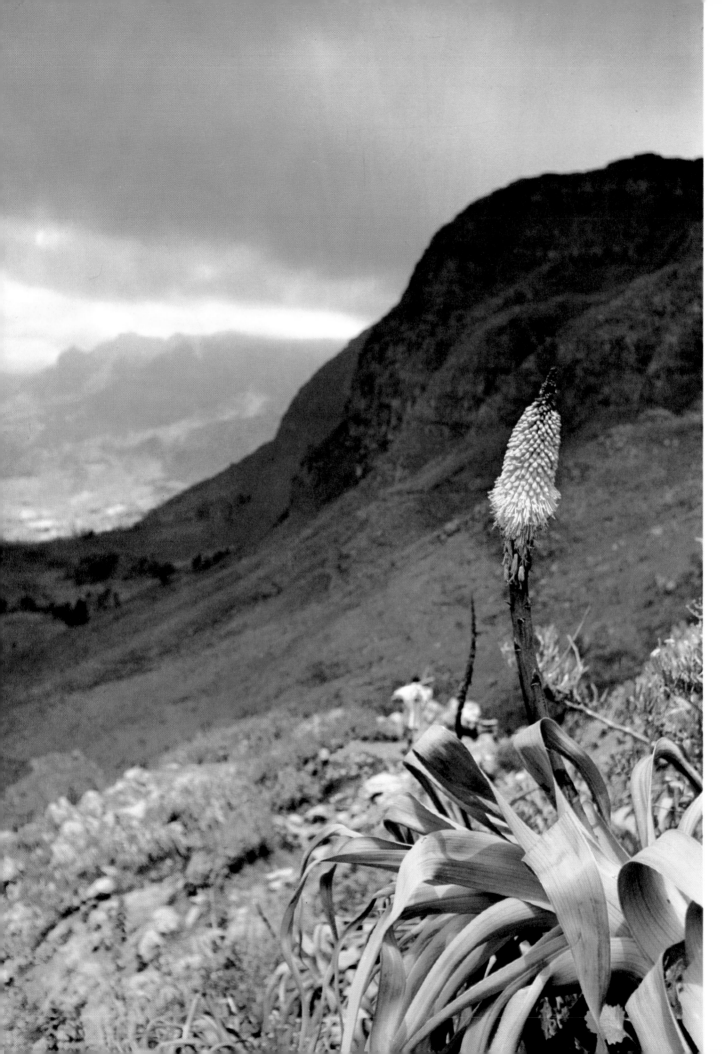

23

22

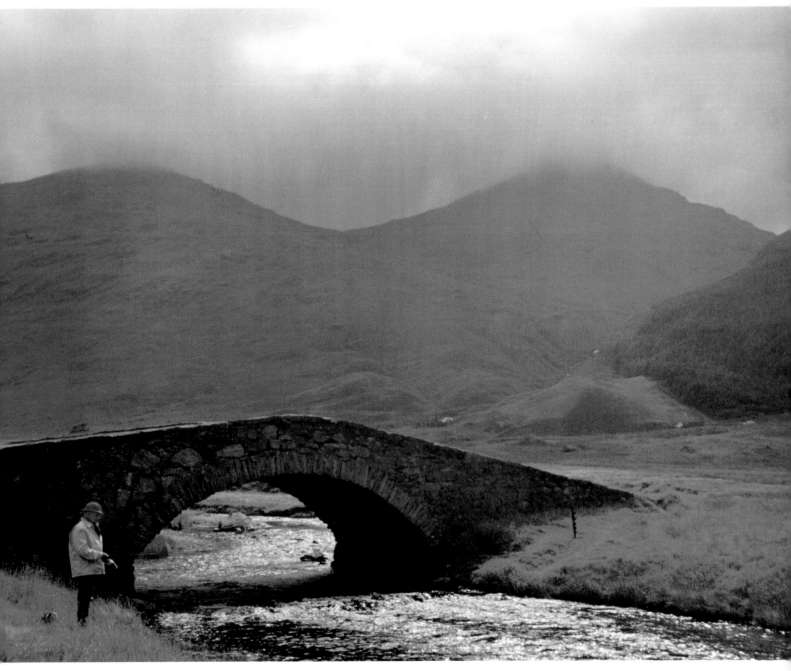

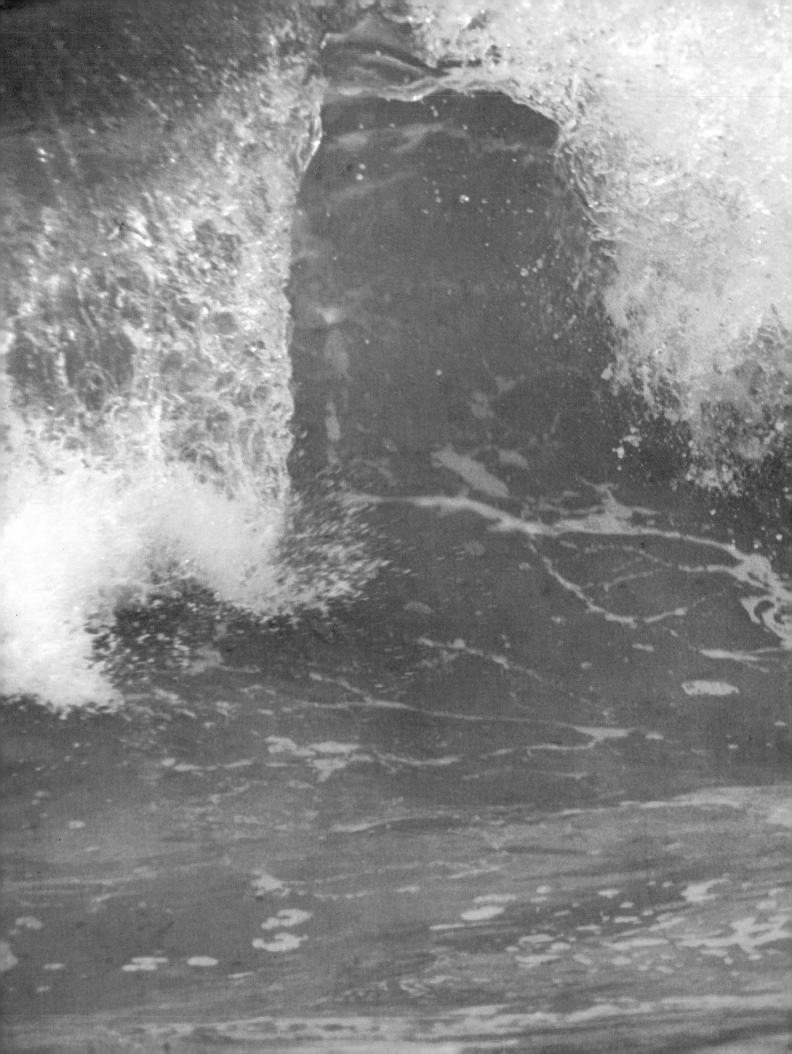

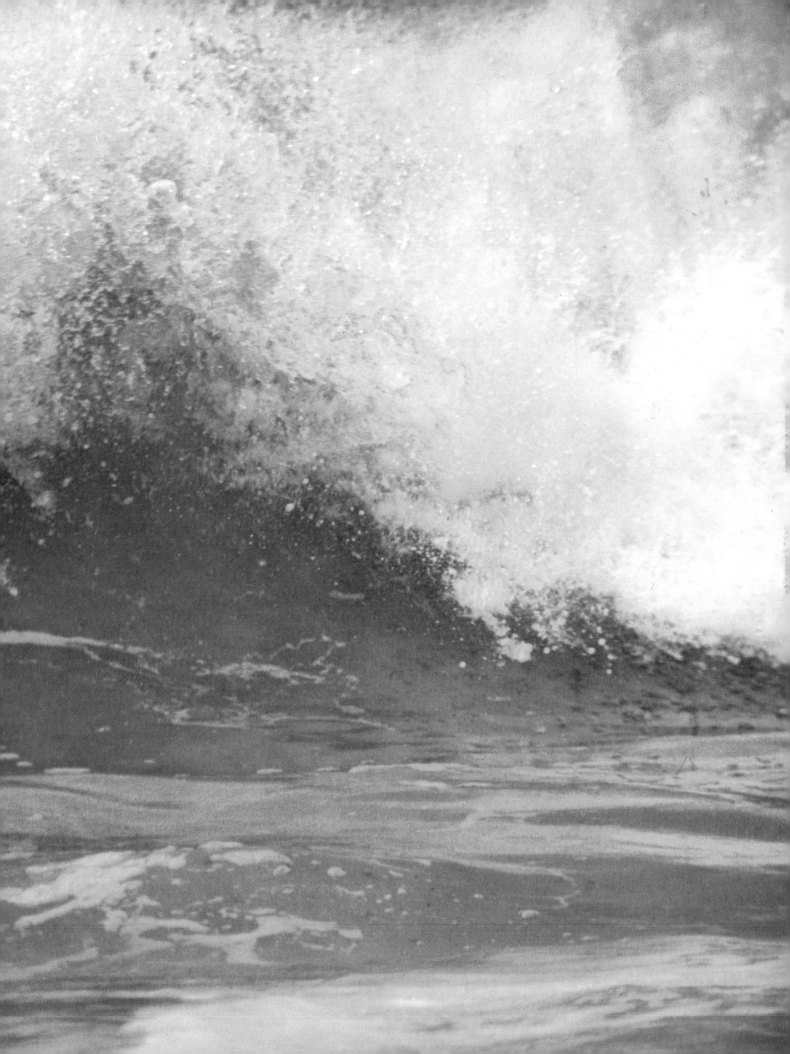

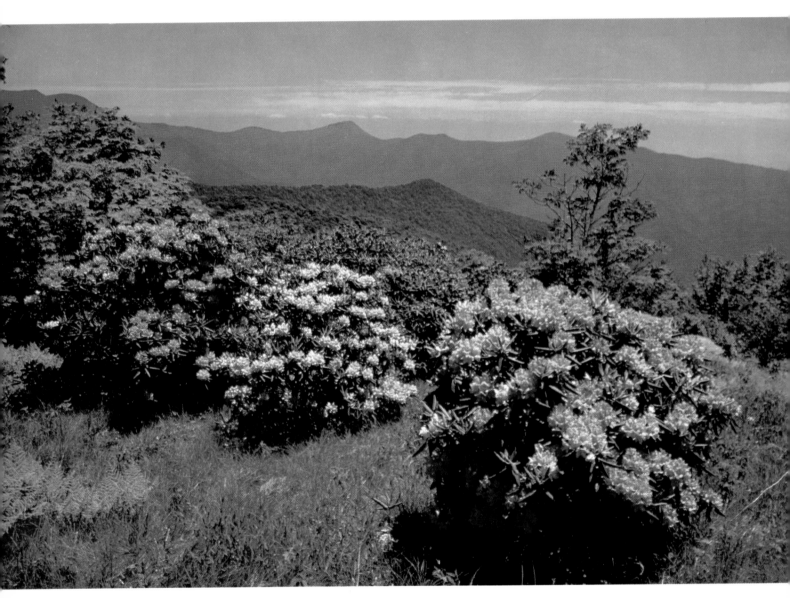

25

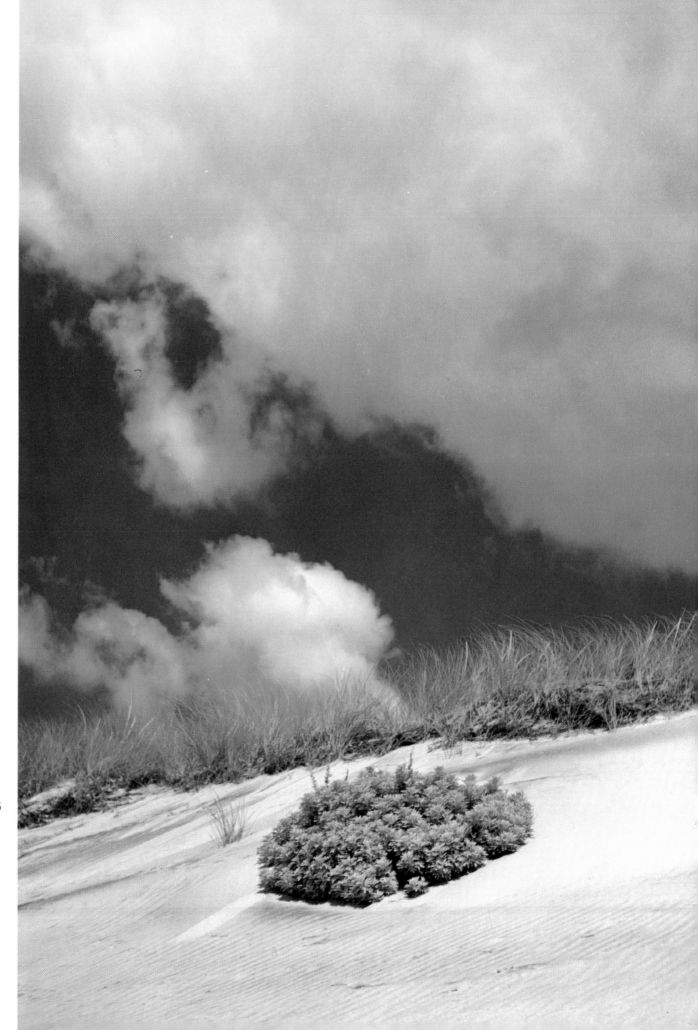

26

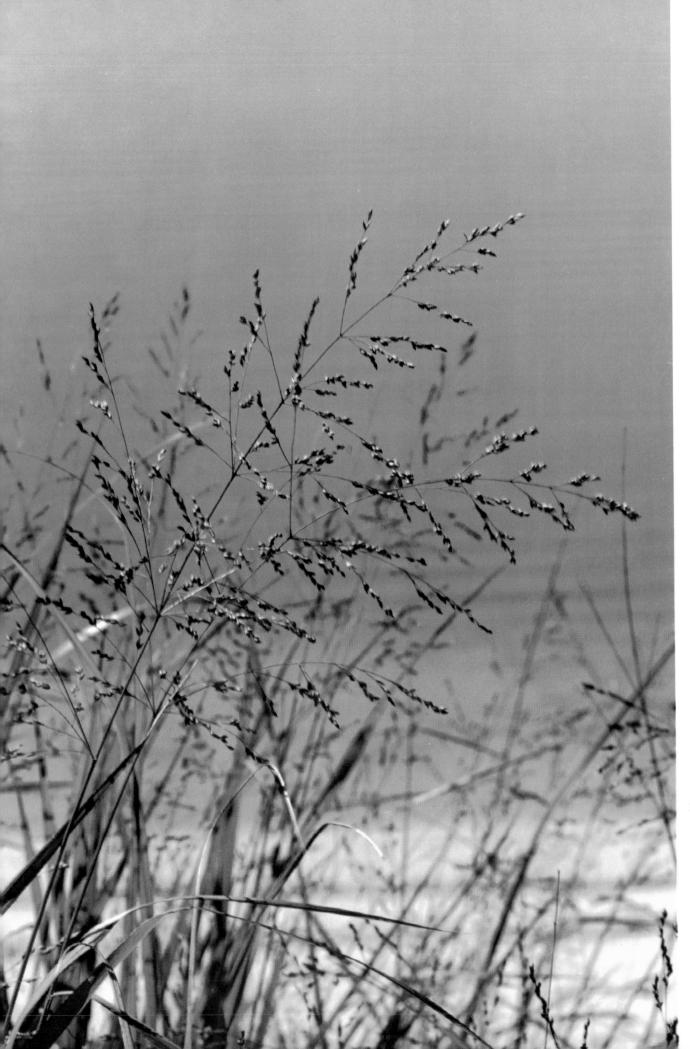

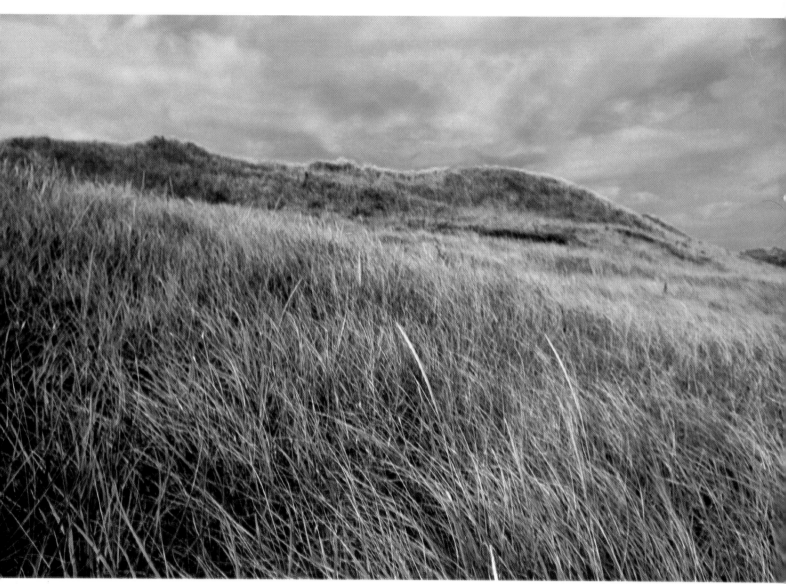

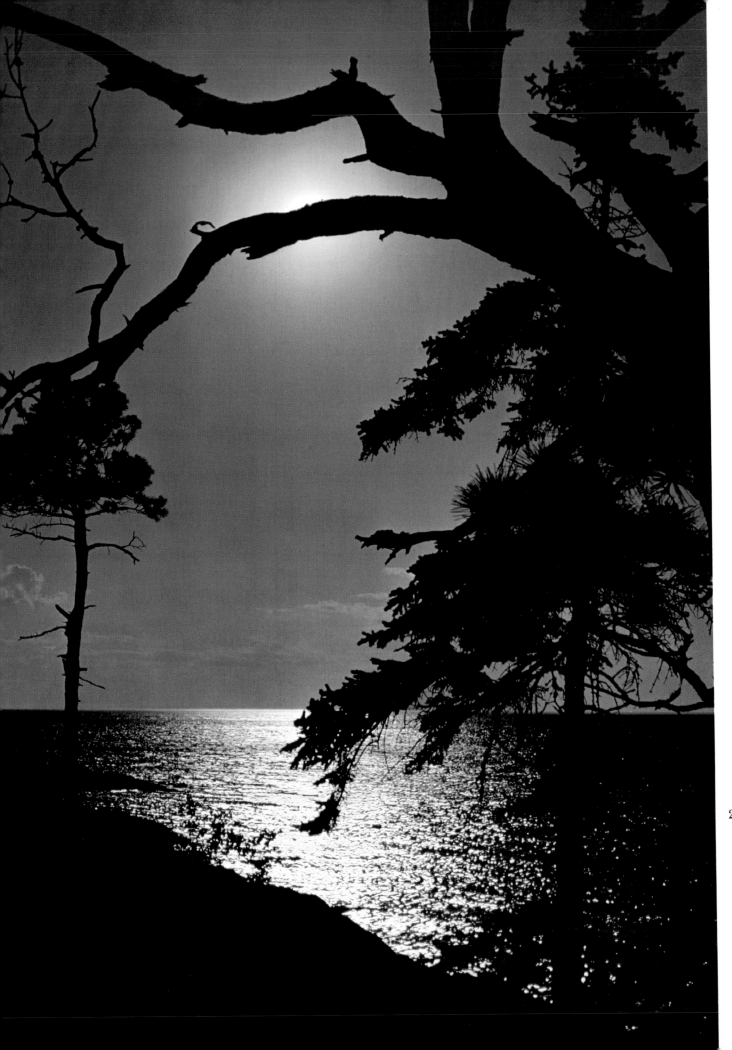

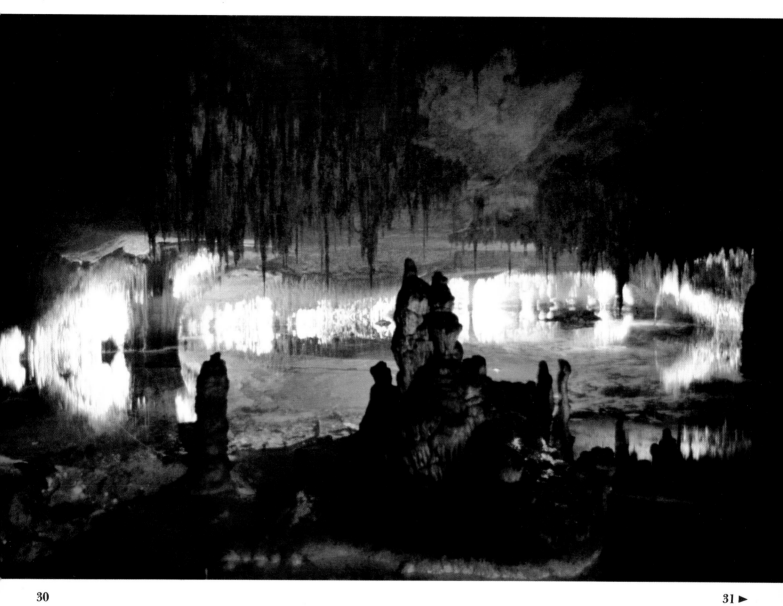

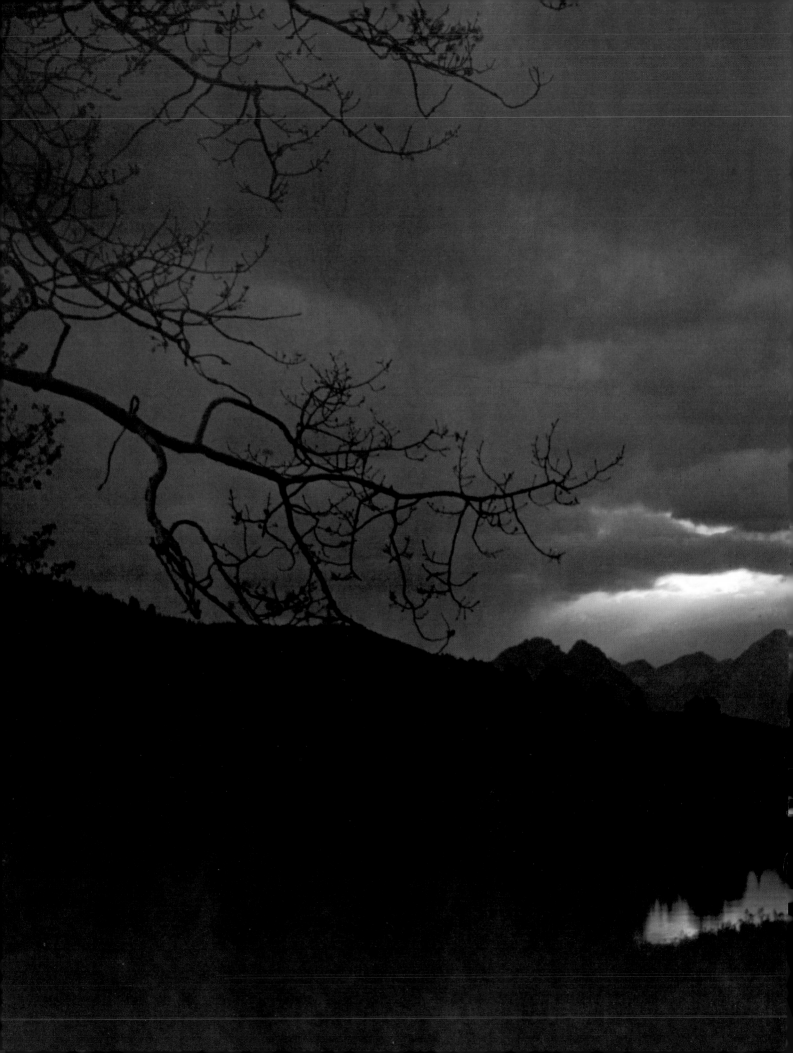

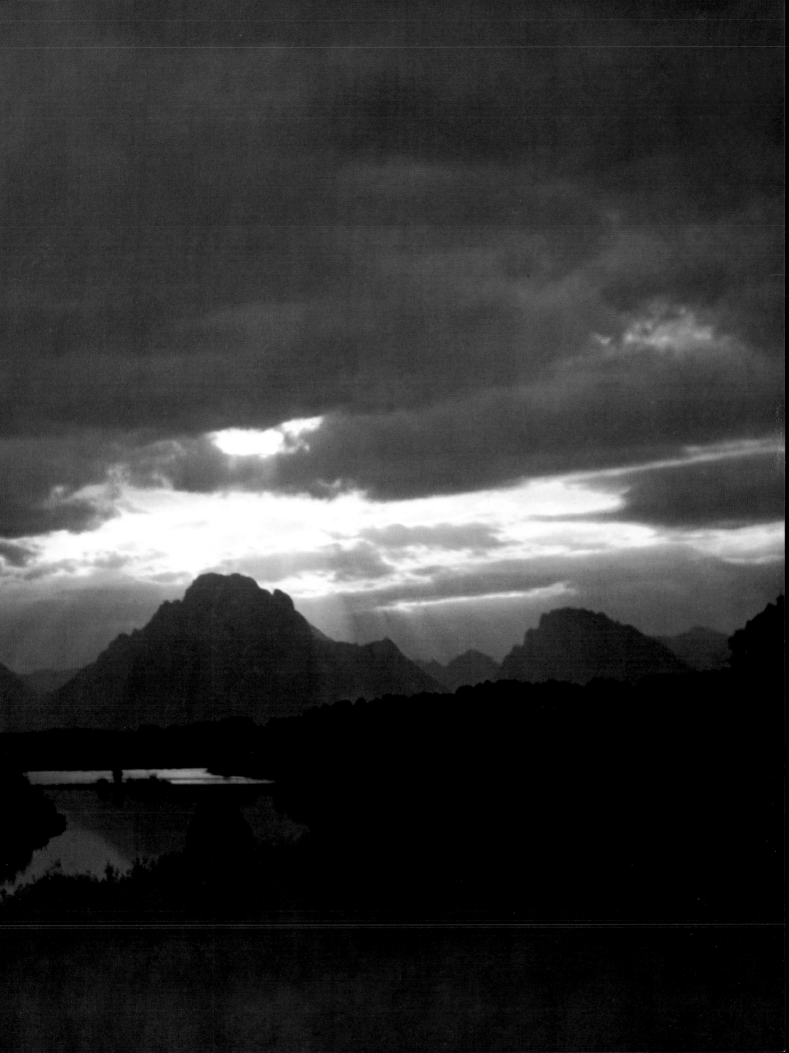

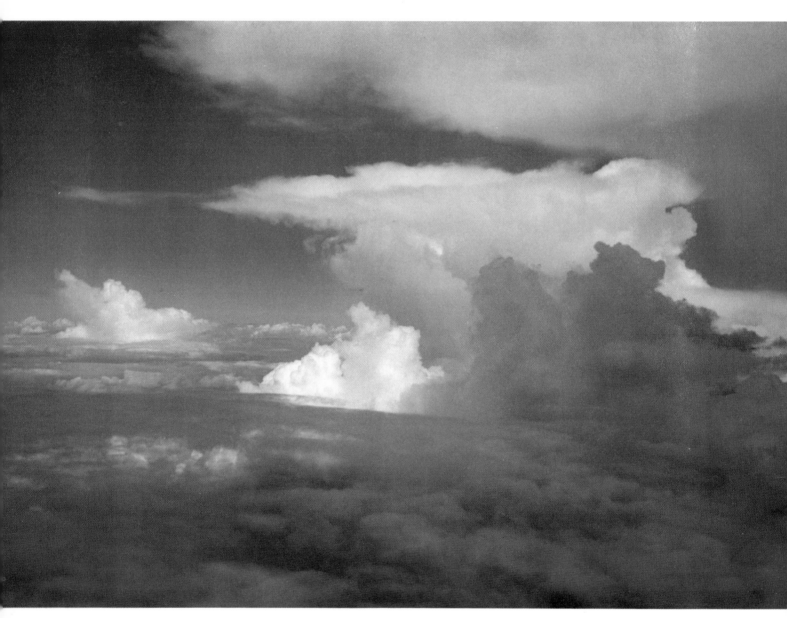

32

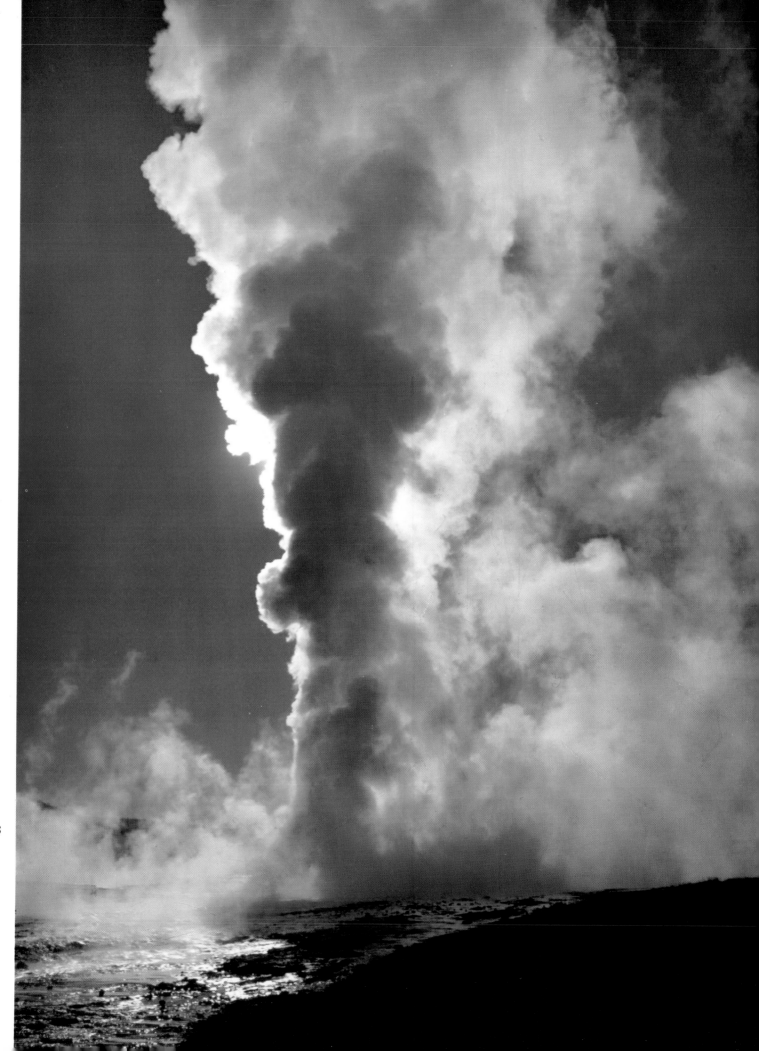

33

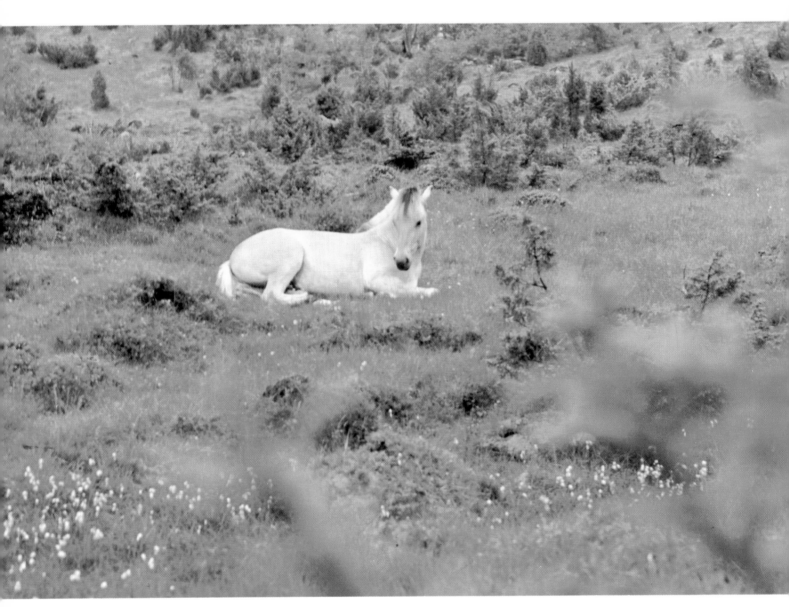

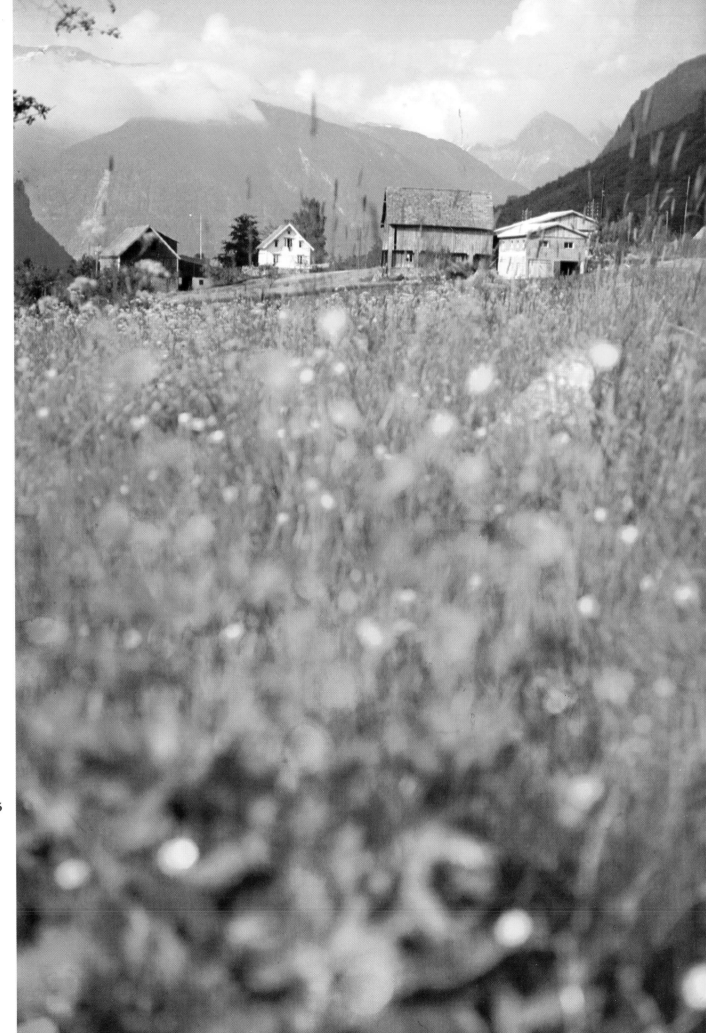

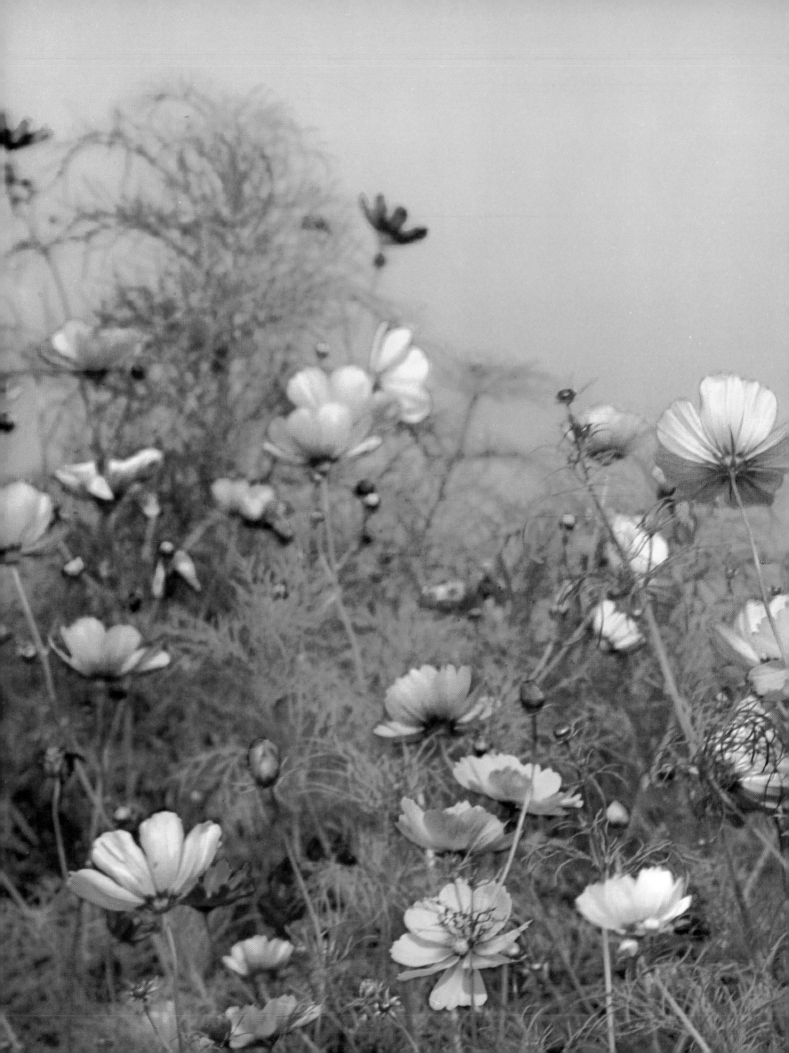

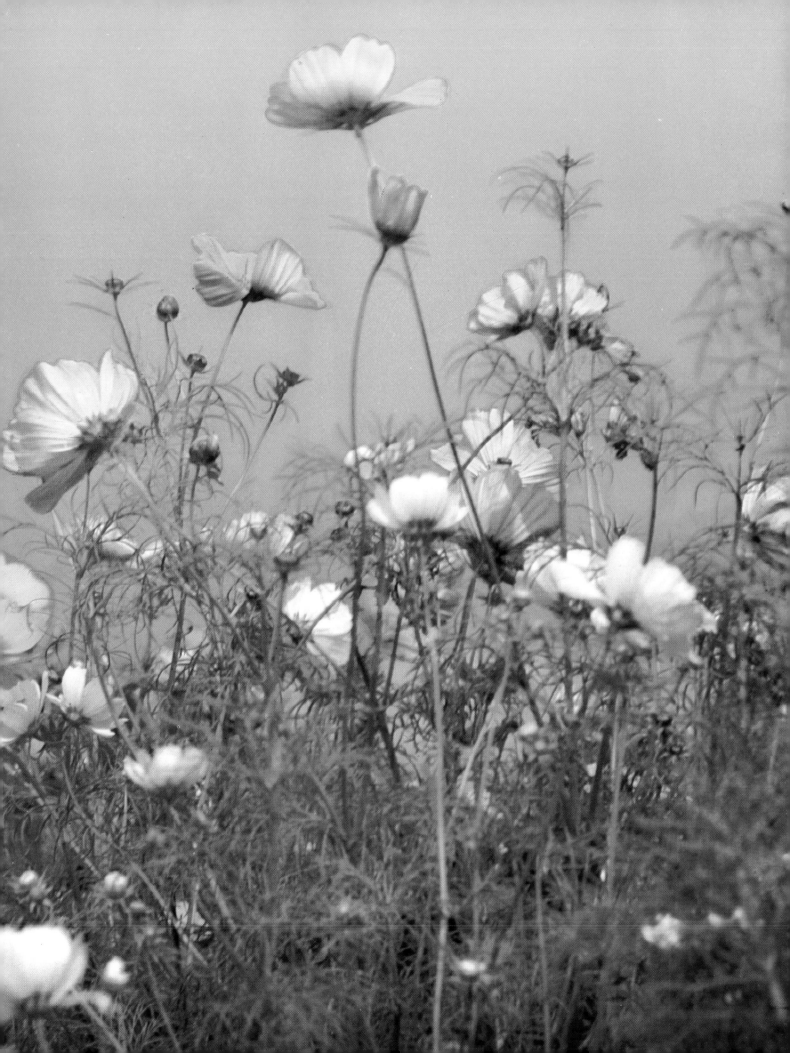

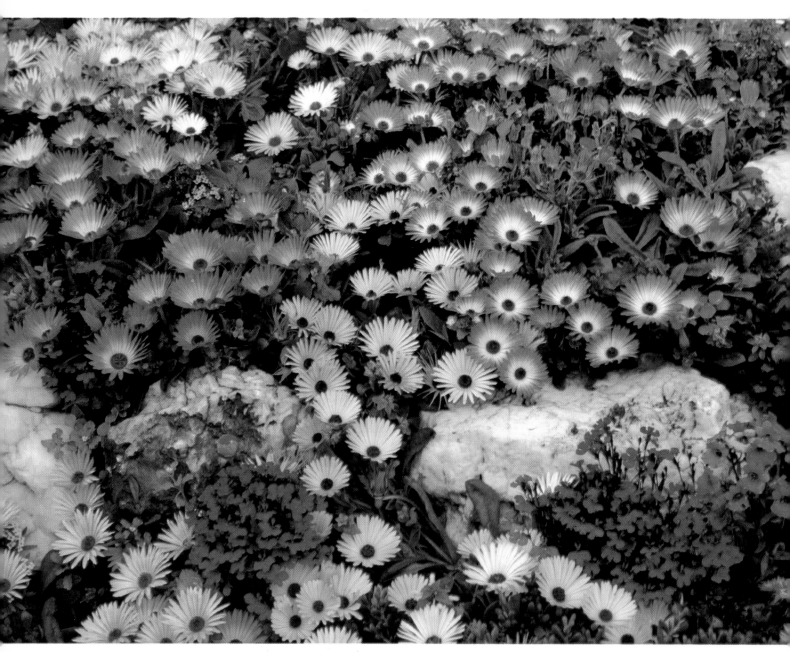

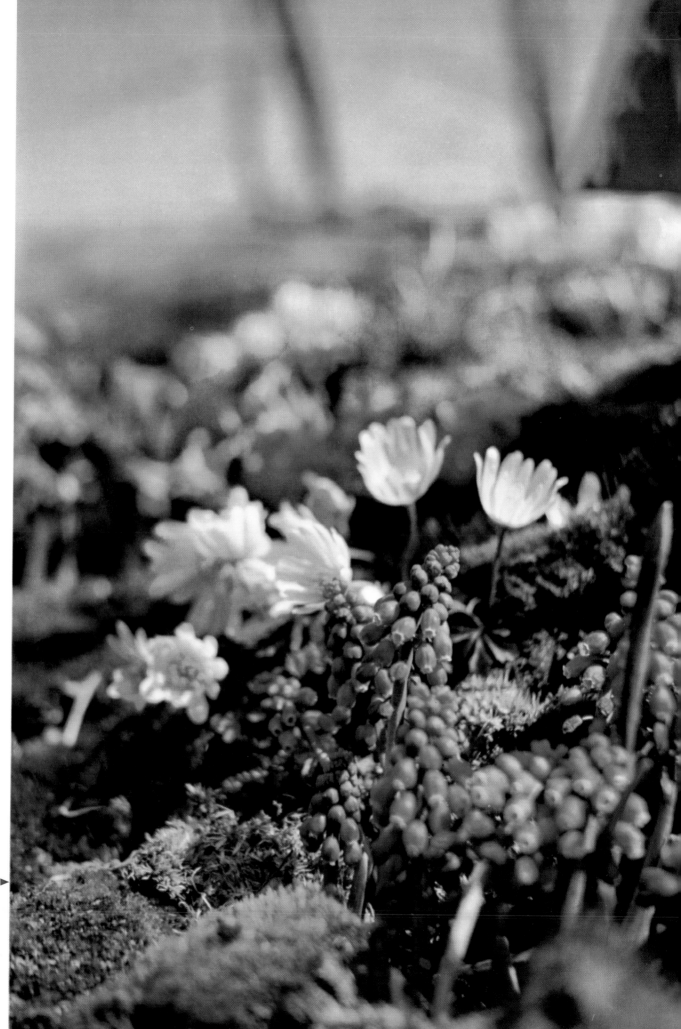

38

39 ▶

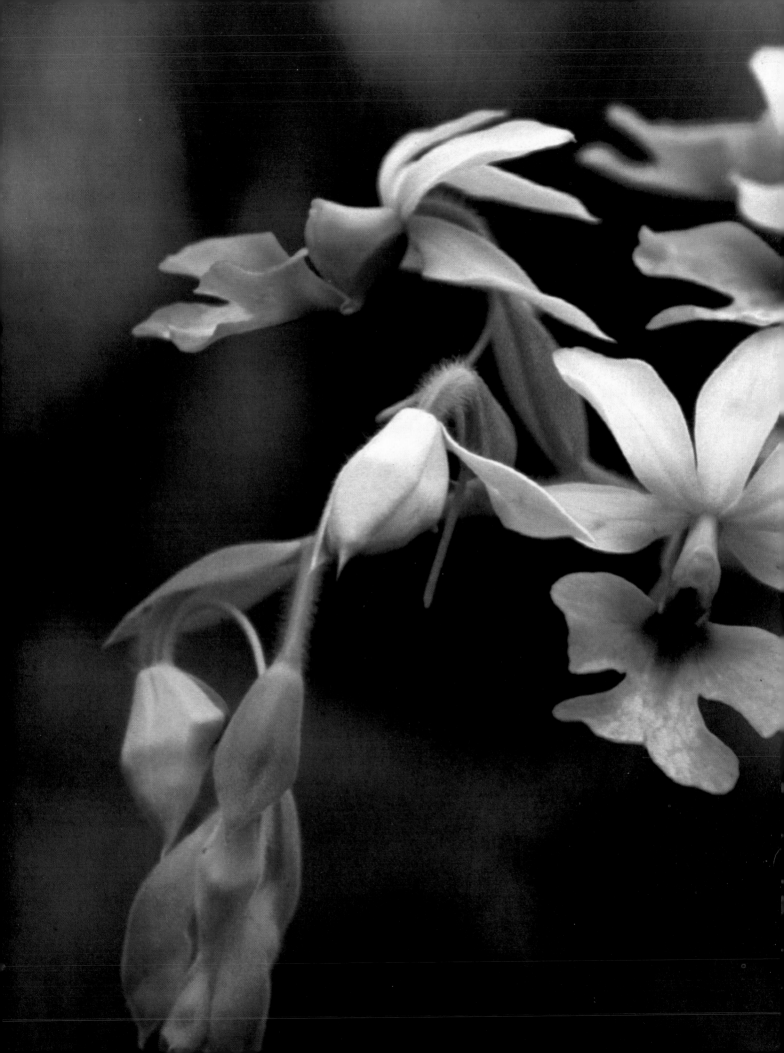

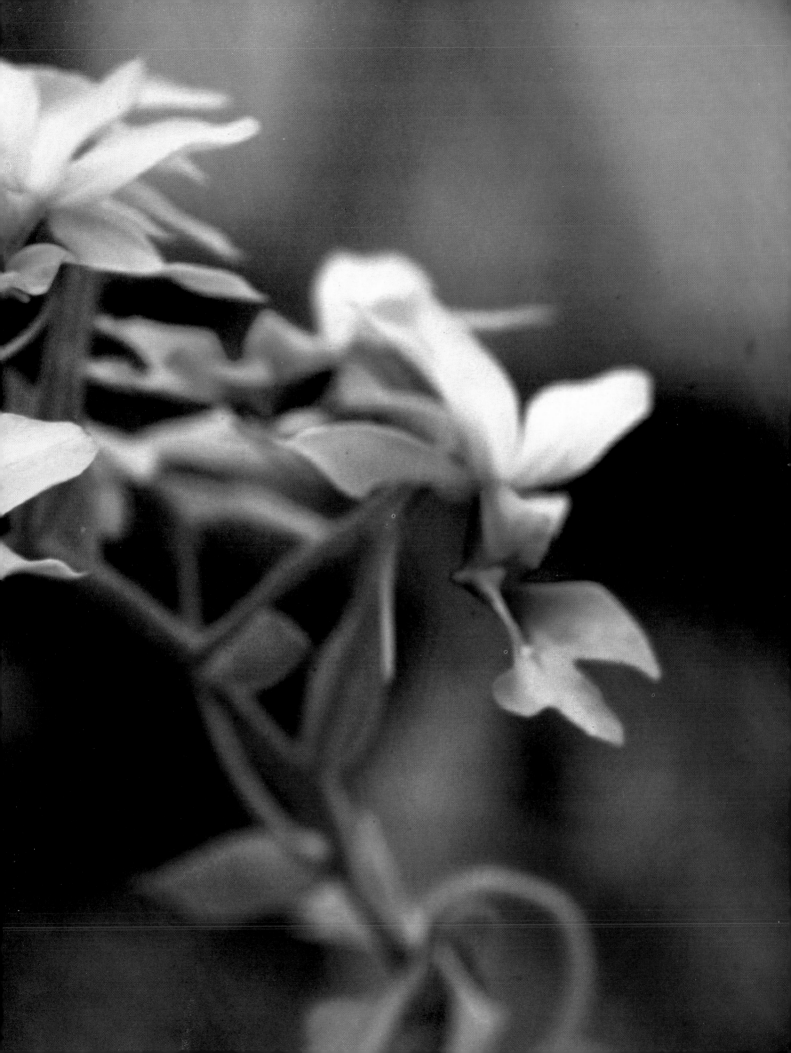

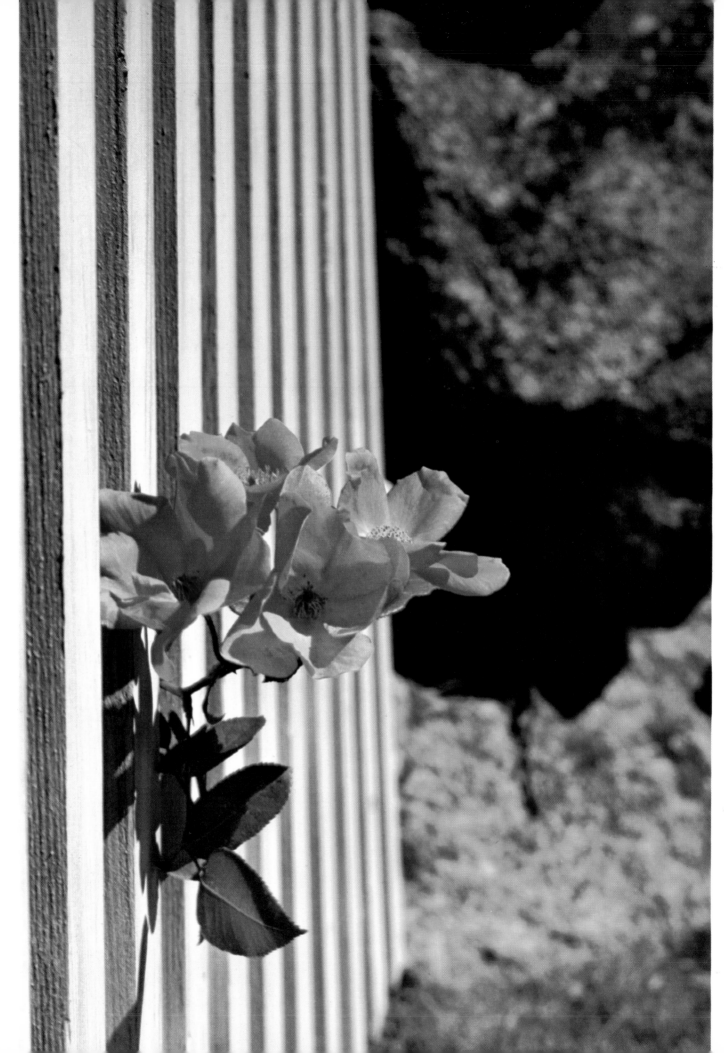

40

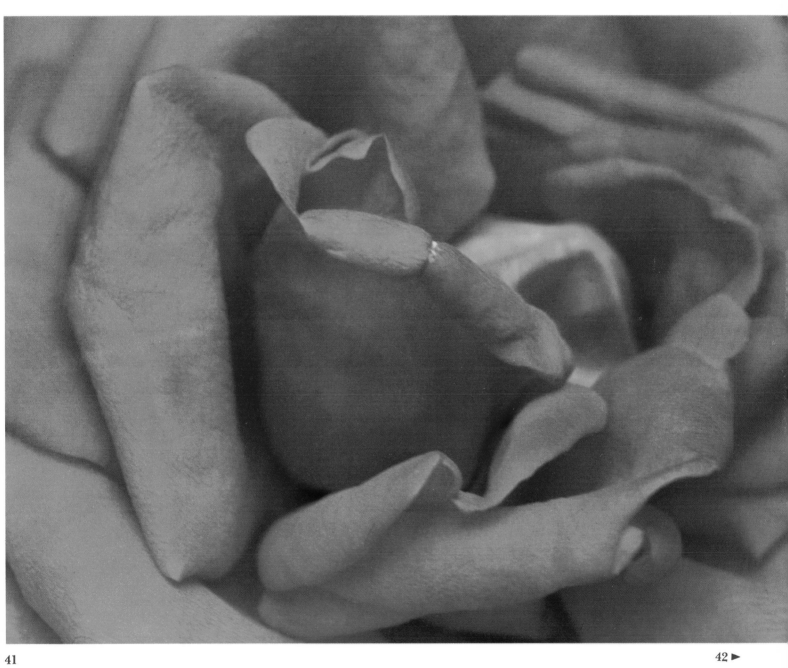

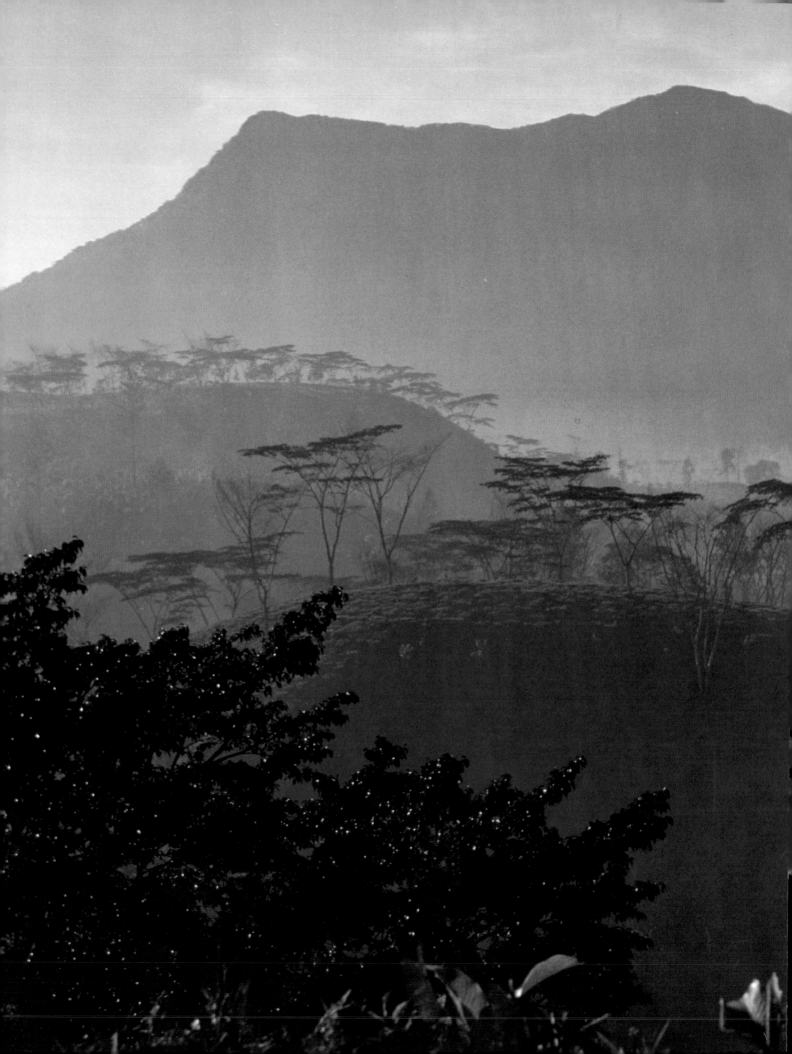

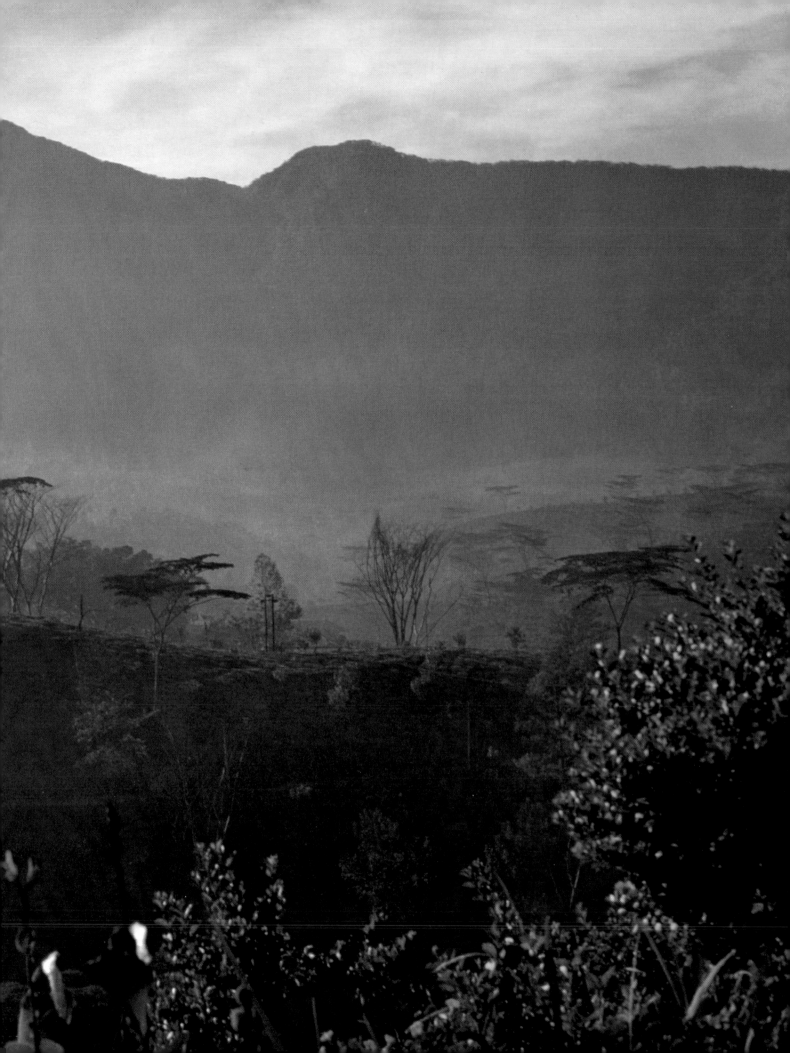

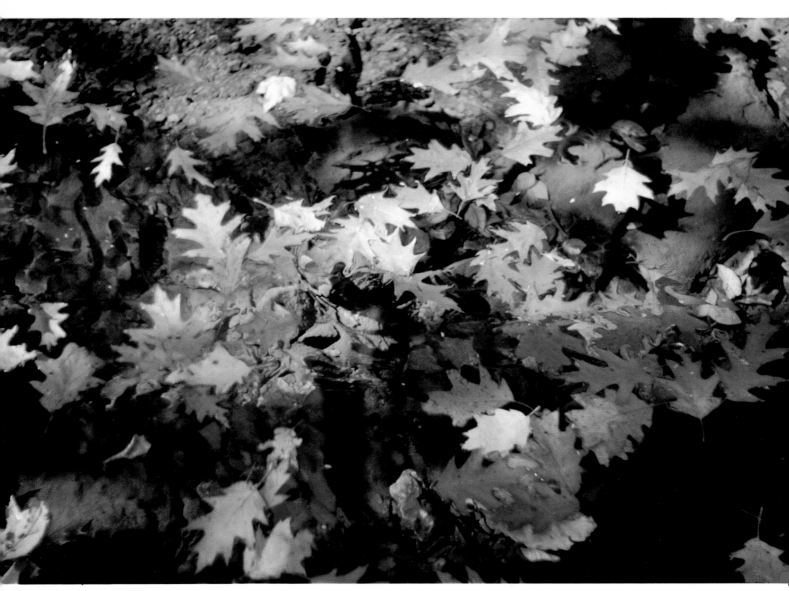

43

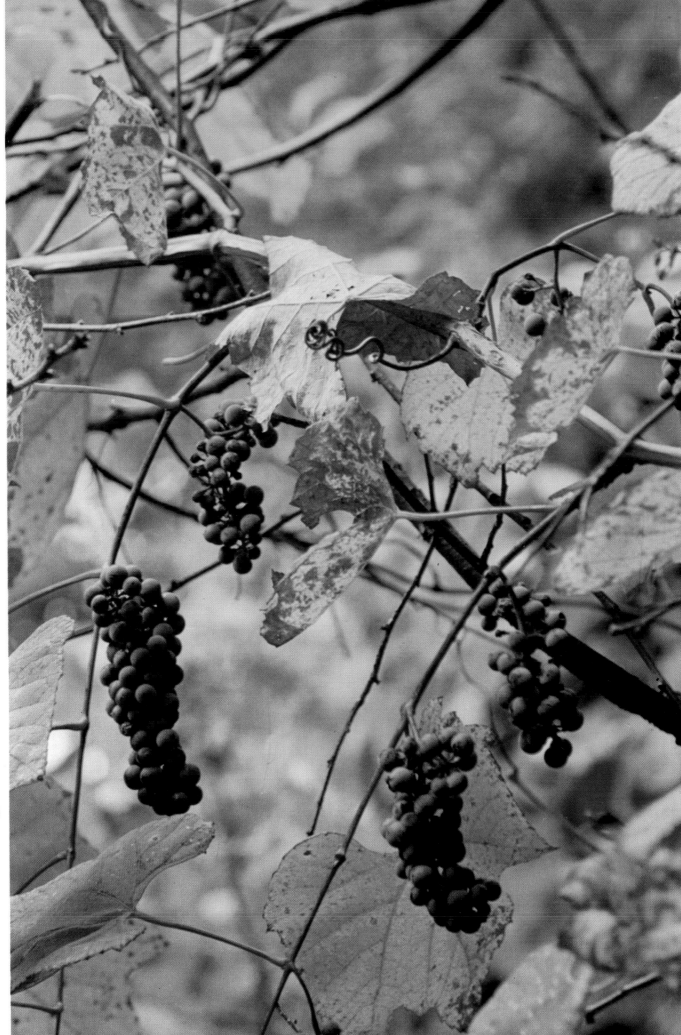

44

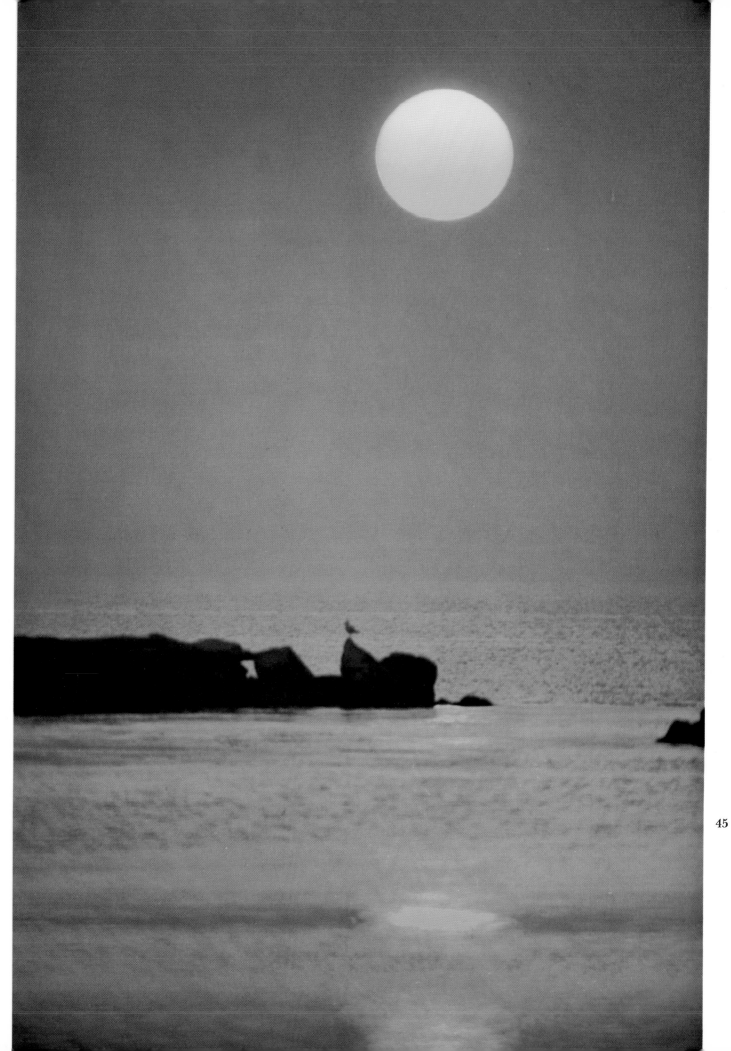

45

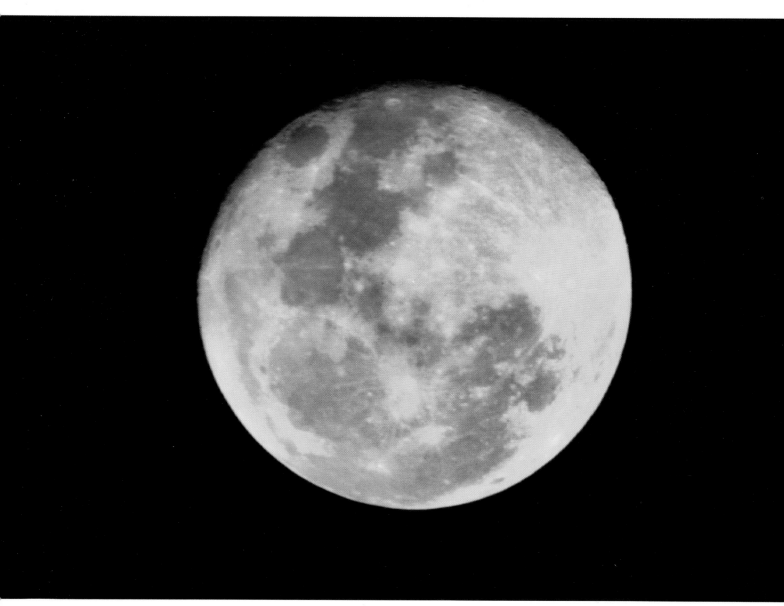

46

III

FORESTS, FIELDS, AND PONDS

The woods and meadows seem most beautiful to me in the autumn, when brilliant color dominates the landscape, but every season has something beautiful to offer, and what you like best may depend a great deal on where you happen to be.

At any time of year, I have found that nature is at its best after a rainfall, when the air is bright and clear and the still-drenched groundcover is sparkling with light. The time to photograph dew-covered weeds and spiderwebs is shortly after sunrise, before the sun has had a chance to dry up all the myriads of tiny droplets left by a gentle mist.

Photographing in the woods and fields is just the same as photographing anywhere else, except that I find myself frequently using a low tripod to get close-ups of all the fascinating little plants that are to be found growing close to the ground. In the dim shade under trees, with the diaphragm closed down to a minimum in order to get maximum depth of field, I must often use quite long exposures, so a sturdy tripod is important here. Out in the fields, where small birds, insects, and butterflies are moving about, telephoto lenses are sometimes necessary to bring these tiny subjects into view.

In some situations, the problems of photographing nature are much more technical than aesthetic. When I was taking pictures in the rain forest of Surinam, for instance, my greatest concern was how to keep my film dry in the super-humid climate. I had to load the camera in six or seven seconds, or the film became too soft and saturated for

use. At night I put all exposed film in a plastic bag with packets of silica gel to absorb the extra moisture. In the morning I took it out of the plastic bags and put it into sealed metal containers, for if you leave film too long in contact with silica gel it dries out too much and becomes brittle. And each day the silica gel had to be put on a Sterno heater to be reconstituted. Fortunately, most of my photographing adventures in the woods have been much less complicated.

NOTES ON PLATES 47–68

47. This forest on Mount Desert Island in Maine was photographed on a dull autumn day when the sky was somber and the light subdued. On other occasions I might have used a Skylight filter to warm things up a little, but doing so here would have spoiled the true mood of the scene and the cool impression of approaching winter.

48. Each year I pay at least one visit to the Mianus River Gorge near Greenwich, Connecticut. The trails over the wooded hills are a delight I look forward to all year, but I save my trips there for early October, when there is a rich variety of color. This is the Havemeyer Falls shortly after a heavy rain. As the light was quite dim around the pool, I set my camera on a tripod, opened the diaphragm fairly wide, and shot at 1/8 second. The slow exposure emphasized the motion of the rushing water.

49. I had been standing hip-deep in the swamp for more than seven hours when I photographed this snowy egret building its nest in a tree. Even though I was wearing waders, my enthusiasm for the venture was not increased by the presence of several water moccasins. My tripod was partly immersed in the murky water, weighed down by my camera and a 400-mm. lens. The area

was heavily shaded and the bird kept moving about, so I had to use a wide-open diaphragm at about 1/60 second.

50. I found this bird's nest at the foot of a lichen-covered tree in the tropical rain forest in the Mapana Creek region of Surinam. Only a few shafts of light penetrated through the underbrush. The lianas and strangler figs that surround these trees often extinguish their lives. I exposed for the deep shade, ignoring the light, so that the details of the tree and nest would not be lost.

51. Here is another view of the scene in Plate 31. By turning it into a vertical picture and using a 400-mm. lens to bring the mountains closer, I completely changed the mood of the scene. In this view, the mountains are much more dramatically overpowering than in the broad, horizontal perspective. This second photograph was taken a little later in the day, when the sun had moved around the mountain.

52. I had to be up long before dawn one chilly November day to get this picture of wild turkeys. The birds move their feeding grounds from day to day, and I wanted to be in a good location, ready to photograph,

76

when the first golden rays of the sunrise began to come through the morning mist.

53. To be a true witness to nature, you have to be able to photograph at close quarters, even in prickly circumstances. These monarch butterflies were photographed with an ordinary 50-mm. lens, and my biggest problem at the time was fighting off the mosquitoes buzzing around my head.

54. This close-up of bumblebees sucking nectar from a thistle was taken with a 105-mm. lens. Fortunately the bumblebees were amiable and let me take their picture quite calmly, without mercilessly pursuing me the way wasps do.

55. I photographed this white-lipped garden snail with a Visoflex and a 135-mm. lens attached to a Leica. I was actually out looking for frogs at the time. The slow pace of the snail made it possible for me to anticipate its progress, so that I was able to focus very exactly for this close-up.

56. A little three-day-old sandhill crane, too young to move about rapidly, was a perfect subject for my camera. Using a short telephoto lens, I circled around it to catch the halo of morning sunlight and photographed with the lens wide open to emphasize the baby bird's downy softness.

57. I waited a long time for the clouds to break in order to get an interesting view of this overgrown pond. I never hesitate to shoot directly into the reflected glare of the sun. It may occasionally spoil a picture, but taking the chance is always worth while. Sometimes you have to disregard all the rules and hope for the best.

58. These spider lilies were photographed in the bayou country of Louisiana on an overcast day. Bright sunlight would have created quite a different mood.

59. It was about dawn when I took this picture of lotuses with a hand-held camera and 35-mm. lens. The blossom in the foreground was just beginning to open its petals as the first rays of the sun reached it.

60. The watchful turtles in the Everglades National Park in Florida are constantly wary; I have seen many of them snapped up by hungry alligators. But this turtle was just sunning itself and in no hurry to leave when I took this picture with a 400-mm. lens.

61. All the rich colors of autumn are represented by these ferns, lichens, partridge berries, and fallen leaves, which I encountered while roaming through the woods one brilliant October day. This is the perfect season for color film; the picture would be relatively featureless in black and white.

62. Perched on a small stool, wrapped in a heavy overcoat, and camouflaged by a tarpaulin, I spent four hours waiting in a place where I knew deer were likely to appear before these two does came into view. My camera, with a 400-mm. lens, was already adjusted on the tripod in front of me, exactly at eye level. I pressed the release as slowly as I could, but the click of the shutter must have alarmed the shy animals, for I was able to take only three or four exposures before they sped away.

63. The October leaves had already fallen and the woods were a monotonous grayish-brown when this yellow fungus drew my eye as a flame draws a moth. The close-up was taken with a Leicaflex and 90-mm. lens.

64. The smooth, round berries of the jack-in-the-pulpit stand out in clear contrast to a background pattern of fallen leaves.

65. A 90-mm. lens and a relatively slow exposure were used to photograph this little bird perched amid the foliage of a small tree in a Galápagos forest. The diffused light filtering through the trees silhouetted the bird's sharp profile and helped to bring out the details of its wings.

66. The early-morning light coming from behind my partially shaded subject is very important to this photograph, for without it the outline of the black anhinga would have been much less dramatically distinct against the pond background. In the background a watchful heron waits for its breakfast. I photographed these birds with a 400-mm. telephoto lens.

67 and 68. Two photographs that bring back memories because they were made when my camera was inadvertently loaded with indoor color film. Both times it was evening, and I was afraid that the results would be disastrous but found instead that the color effects were fascinating; my "mistake" had created an eerie illusion of moonlight. The elephants in Plate 67 were grouped around a water hole in Kenya, and the moose in Plate 68 had come to drink at a pond in Yellowstone National Park.

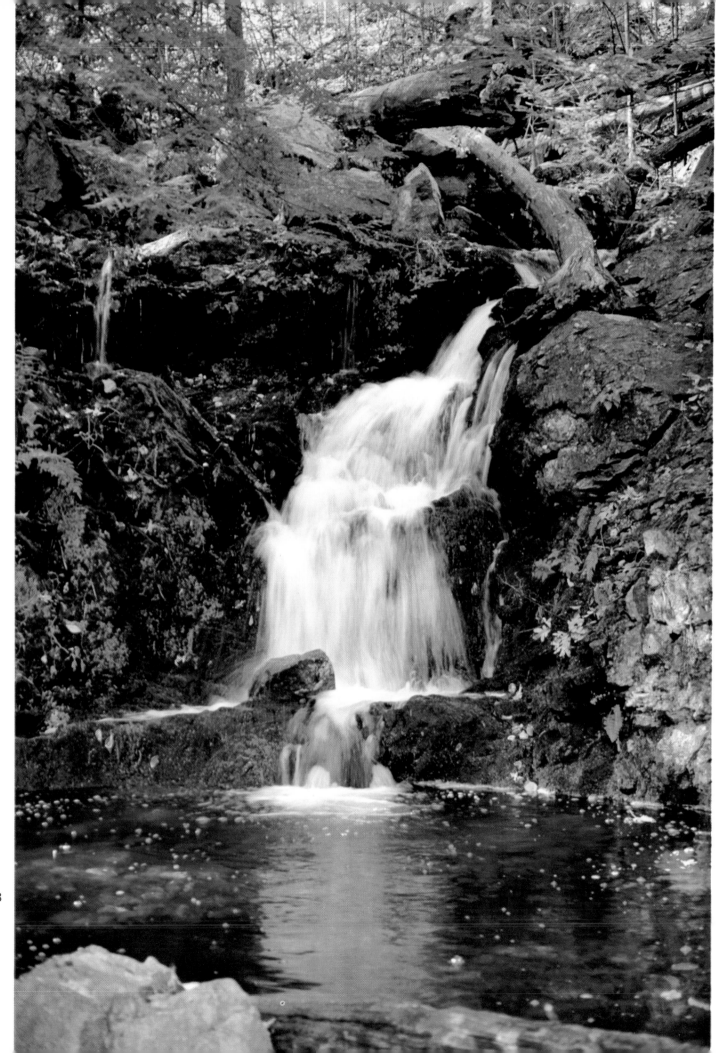

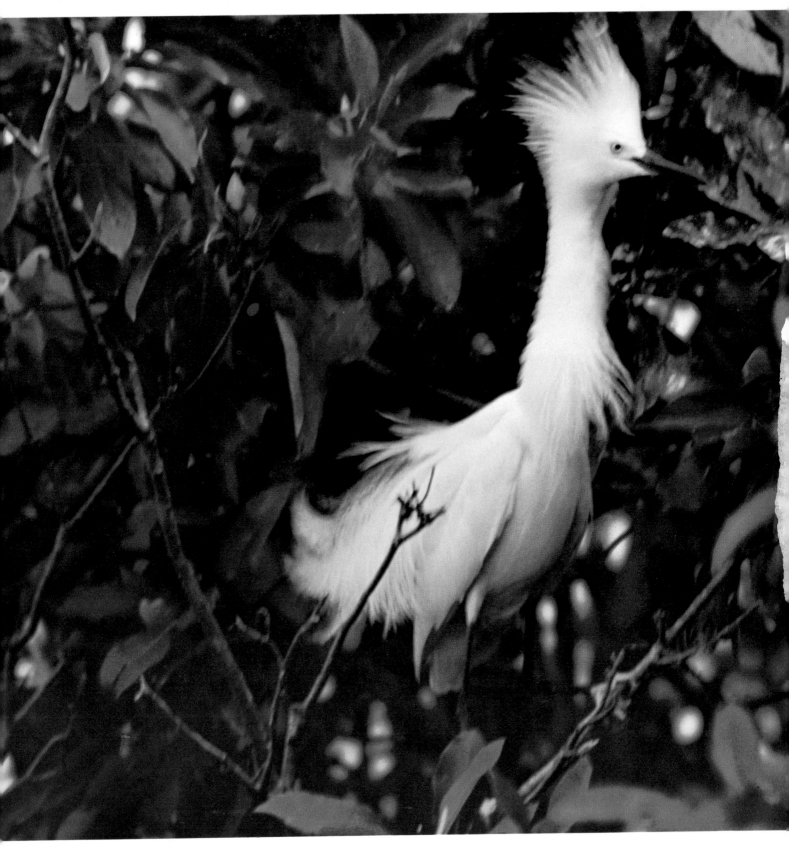

49

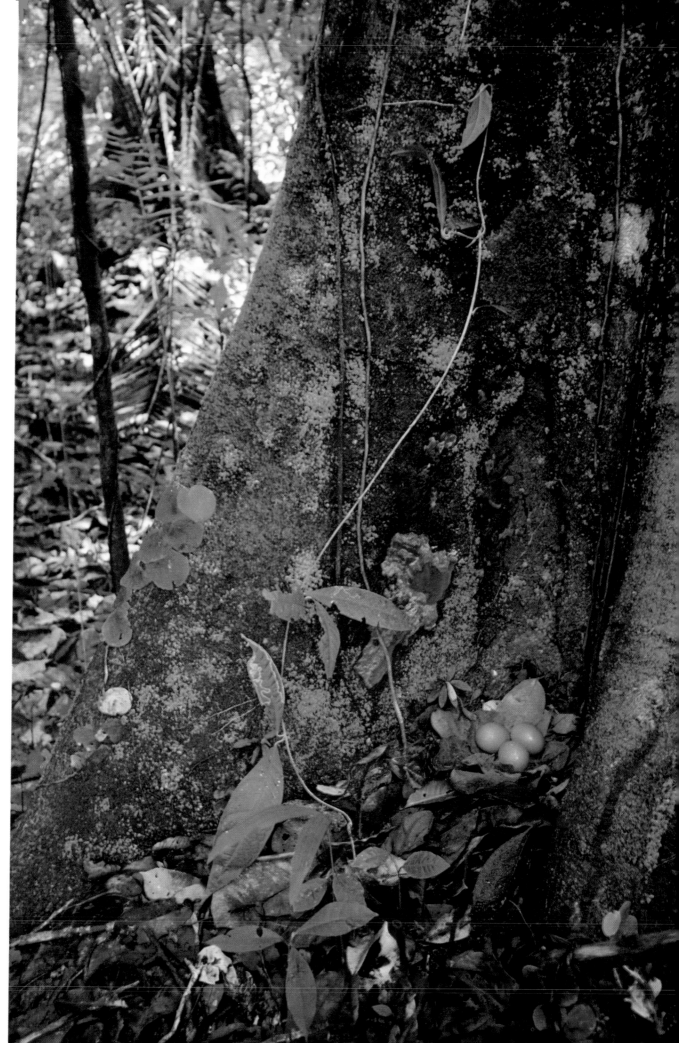

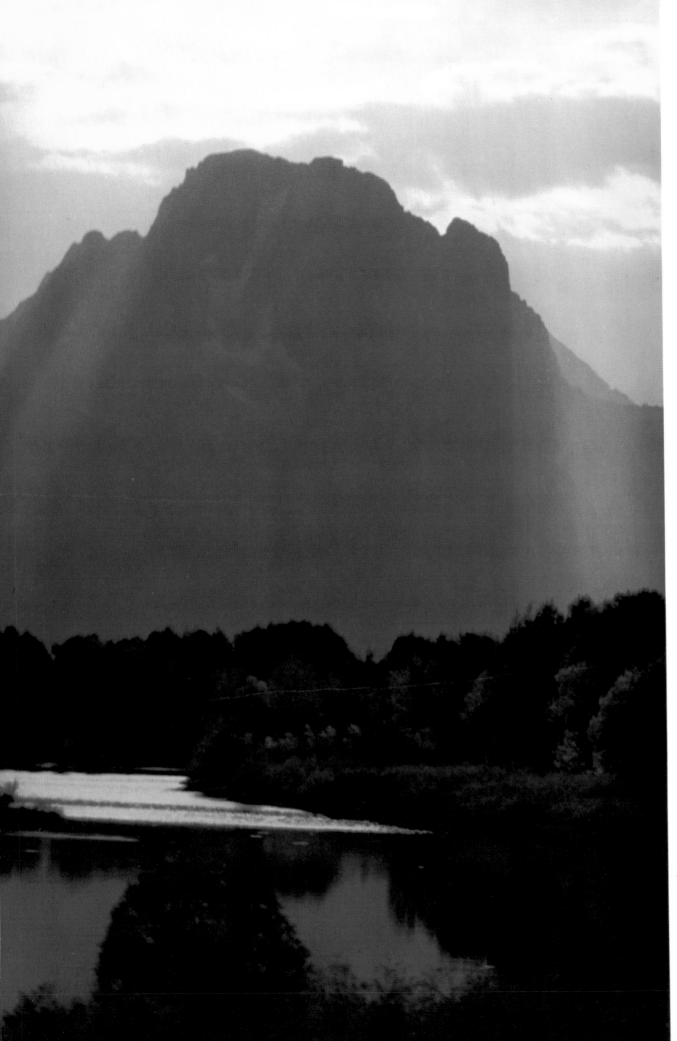

51

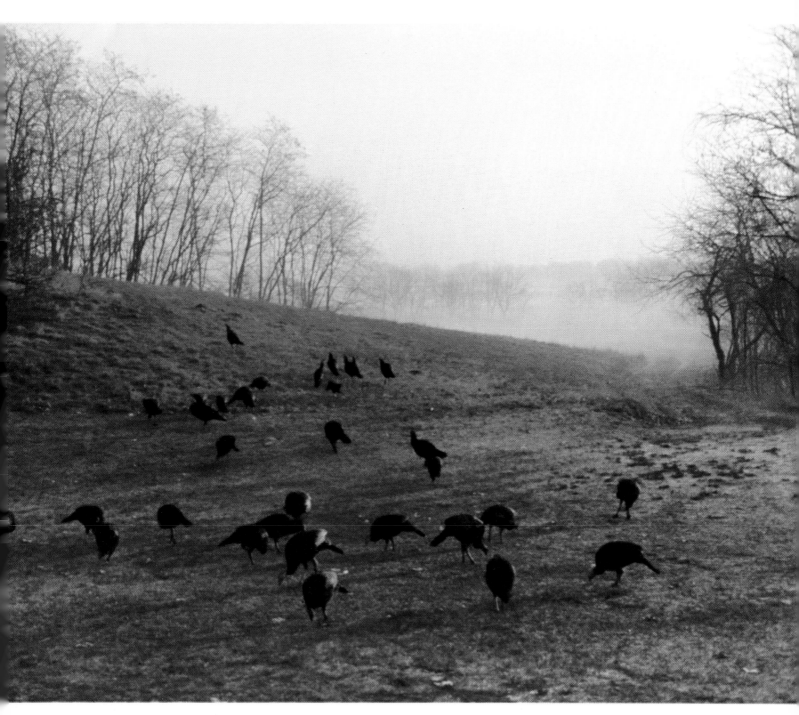

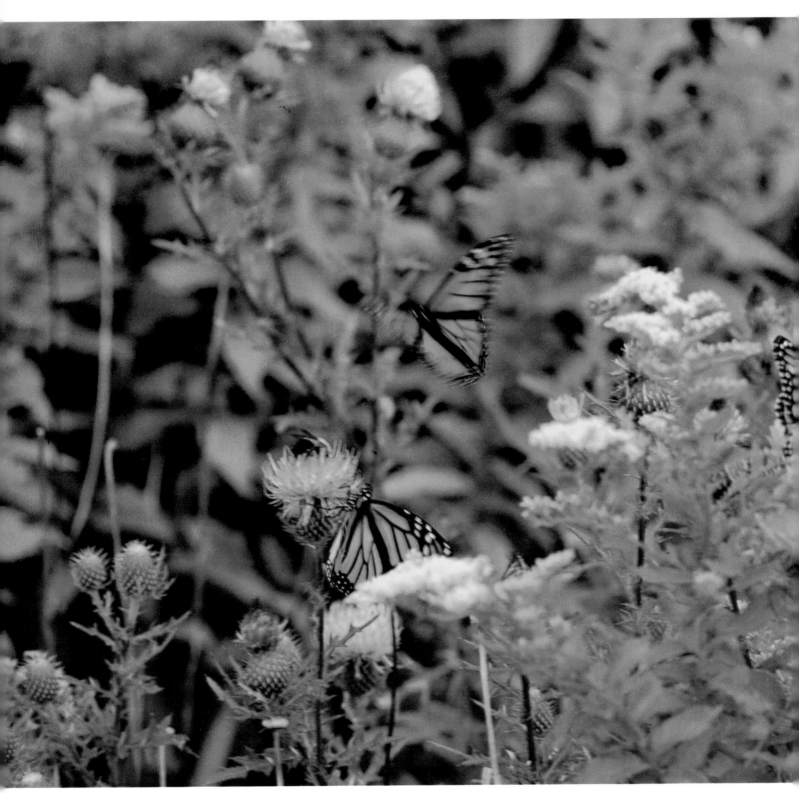

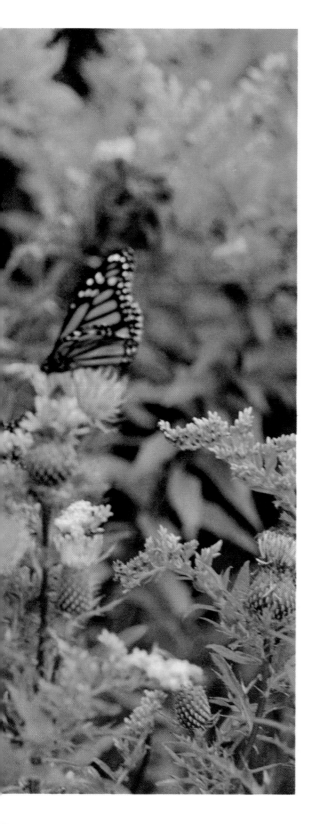
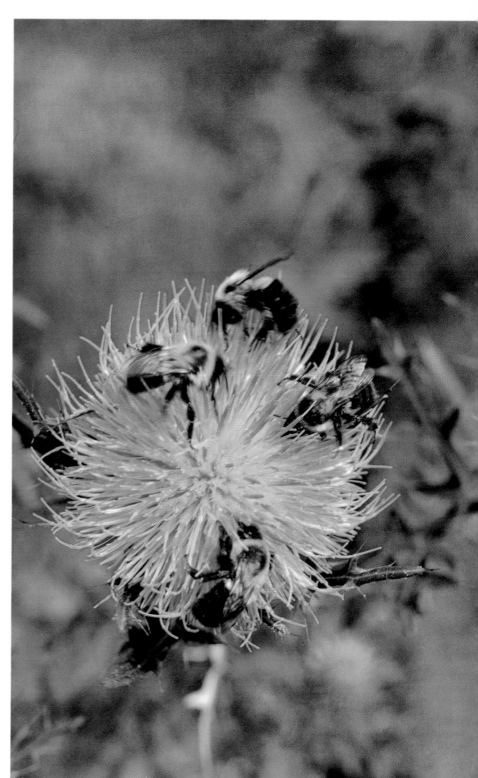

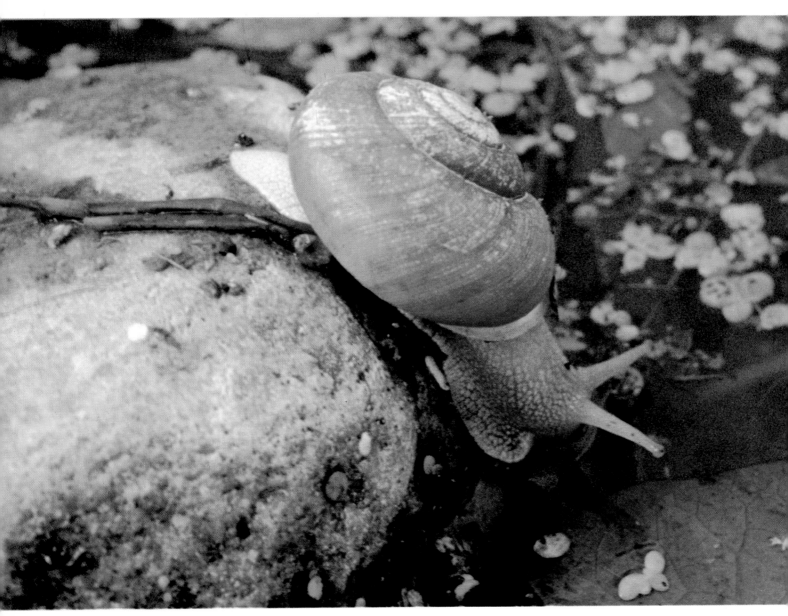

55

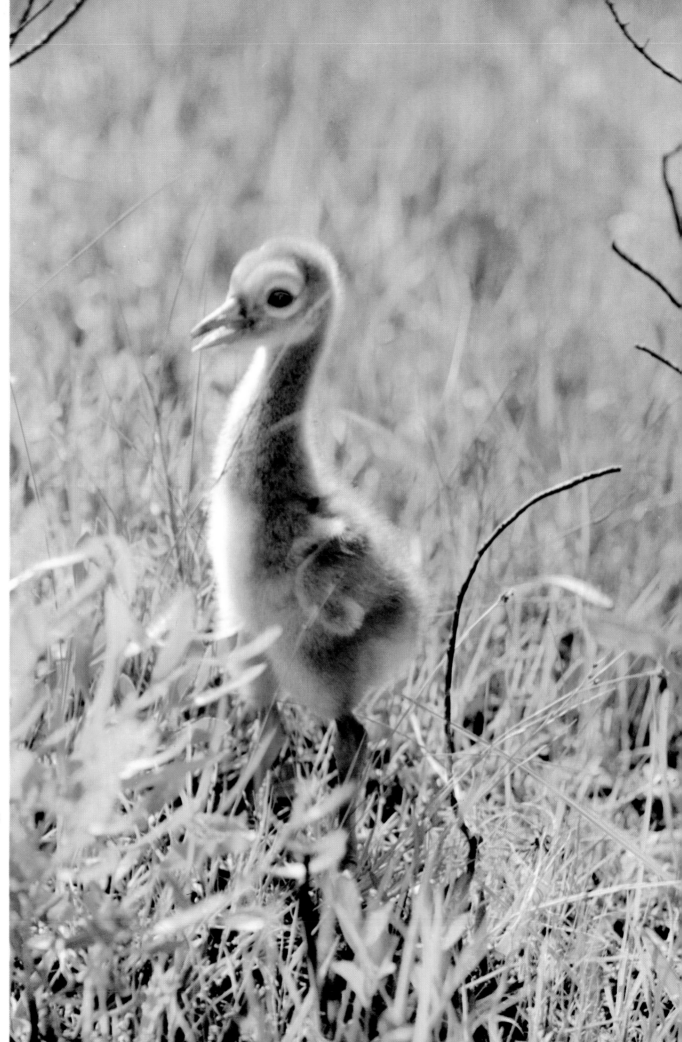

56

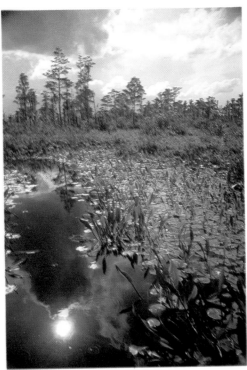

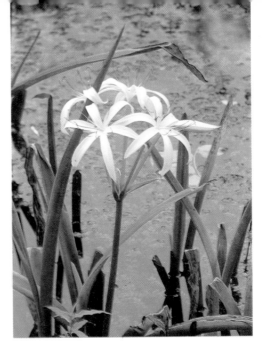

58

57

59

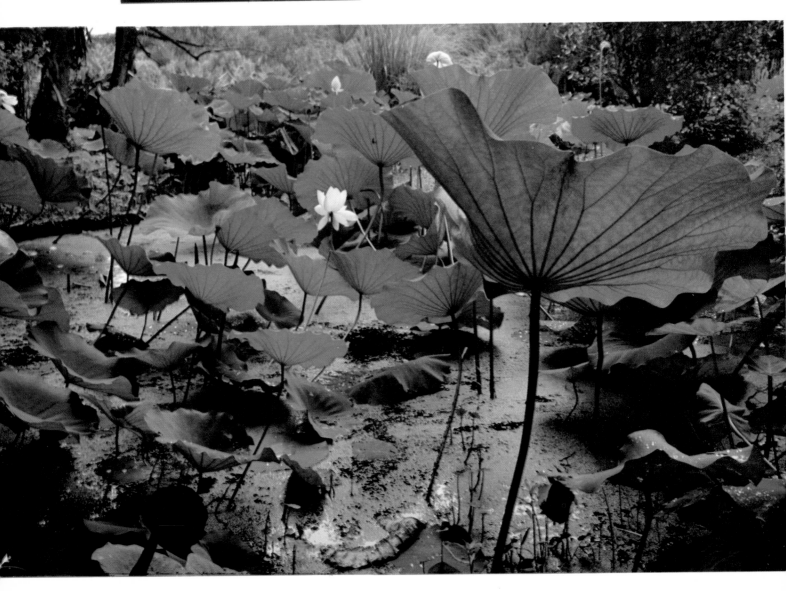

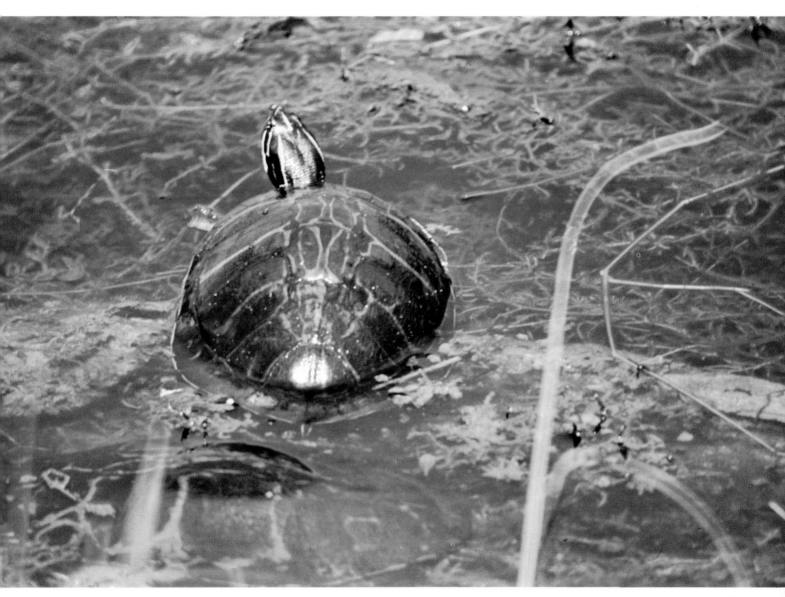

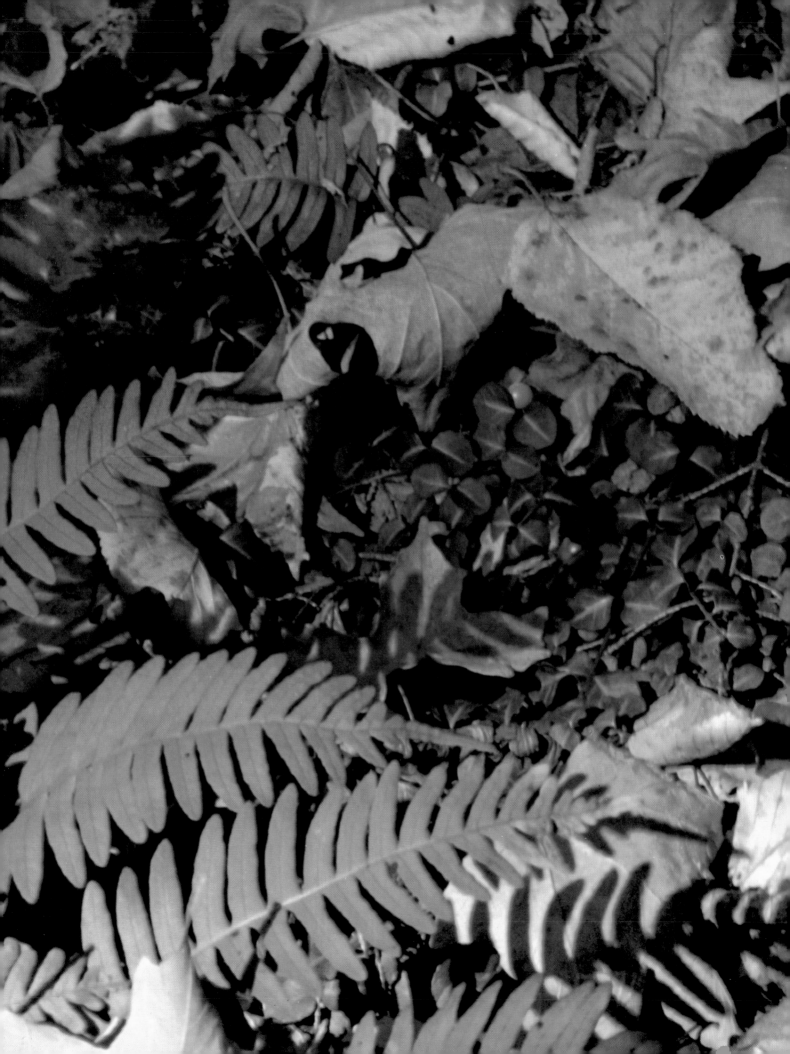

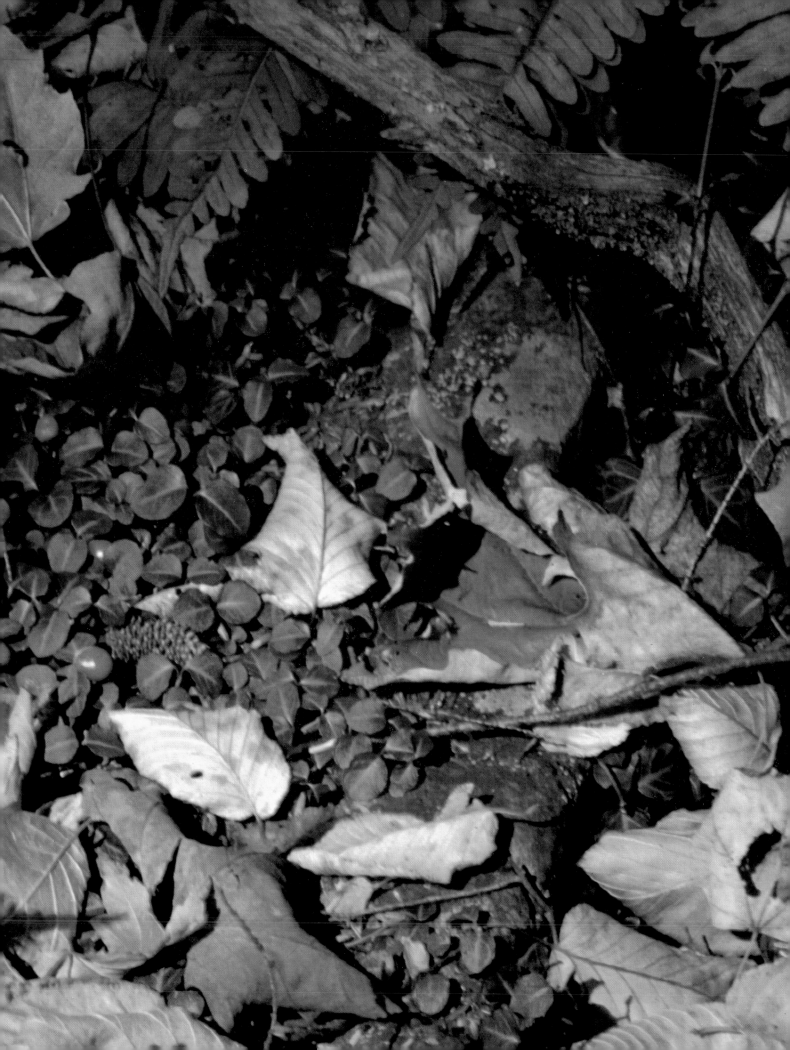

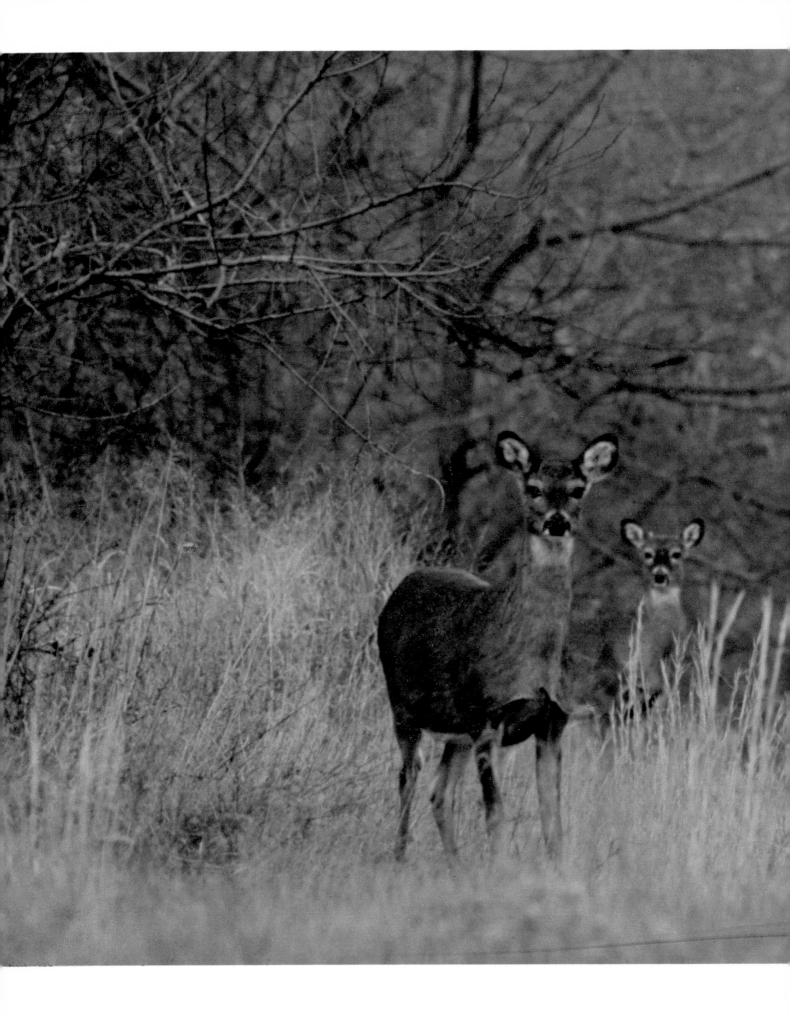

62

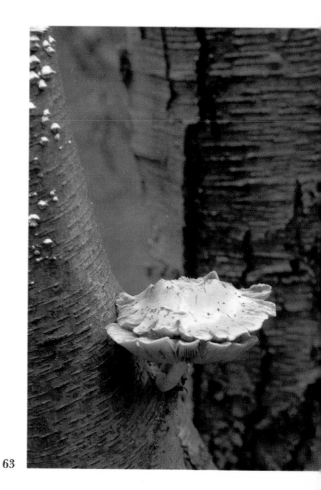

63

64

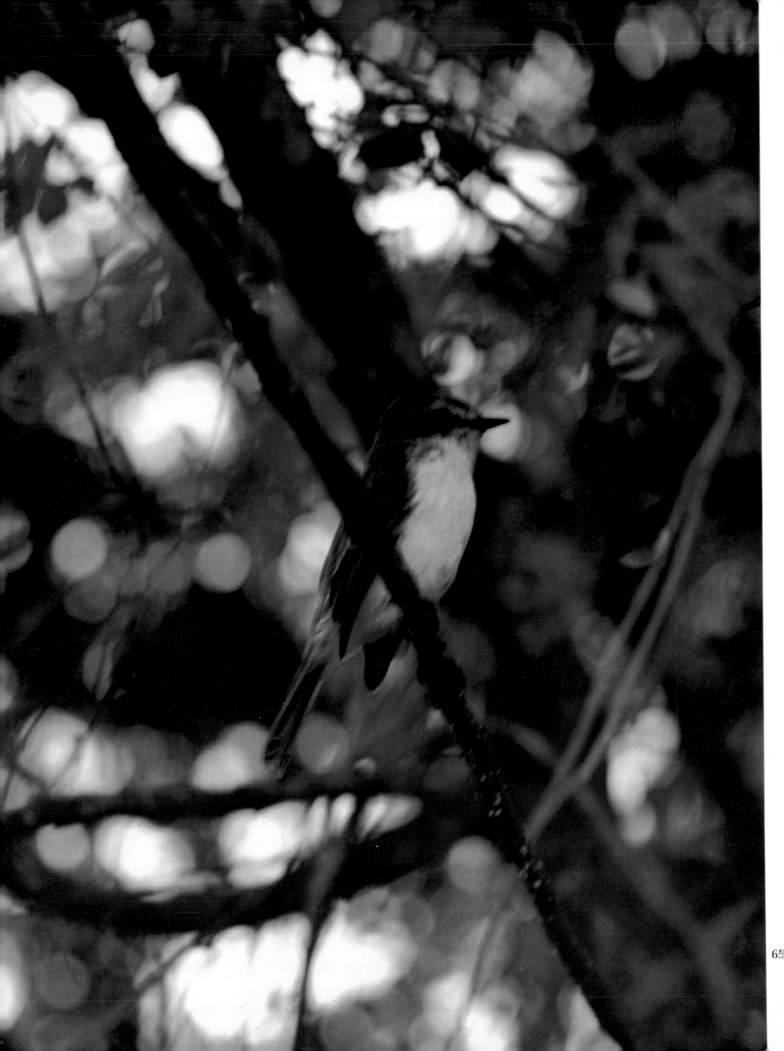

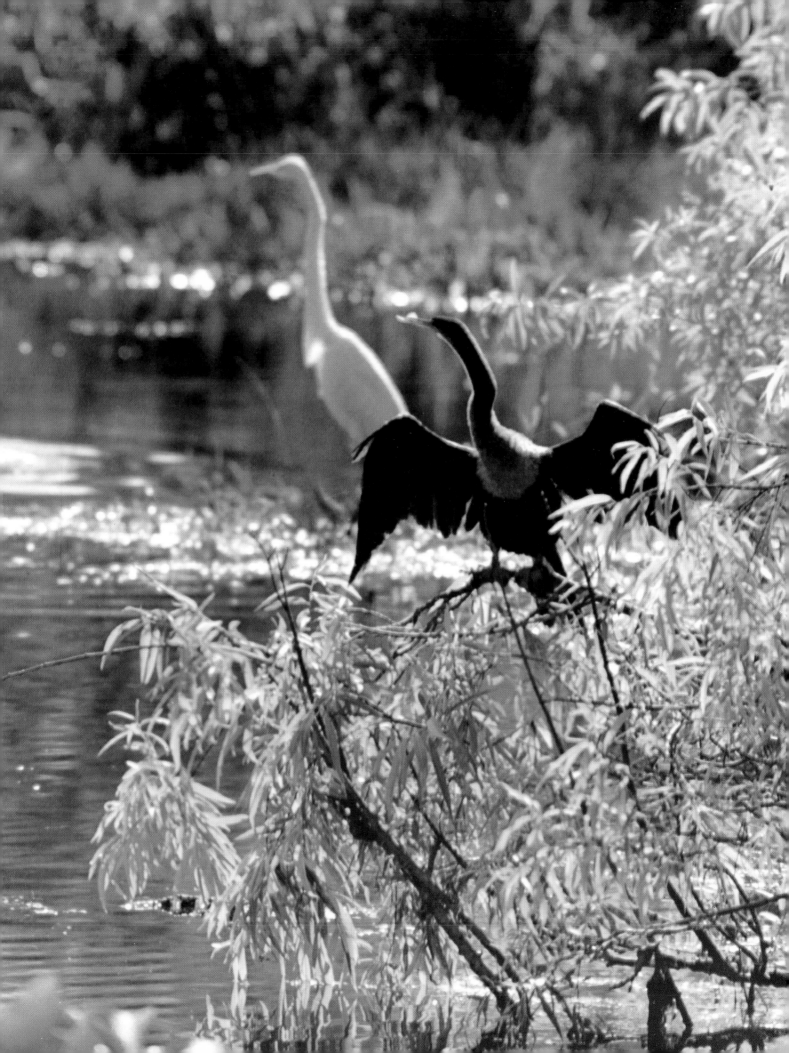

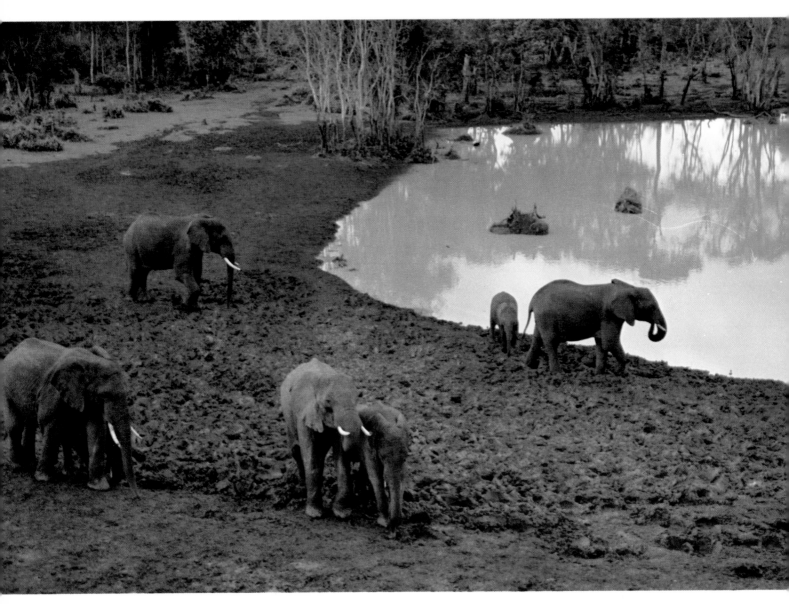

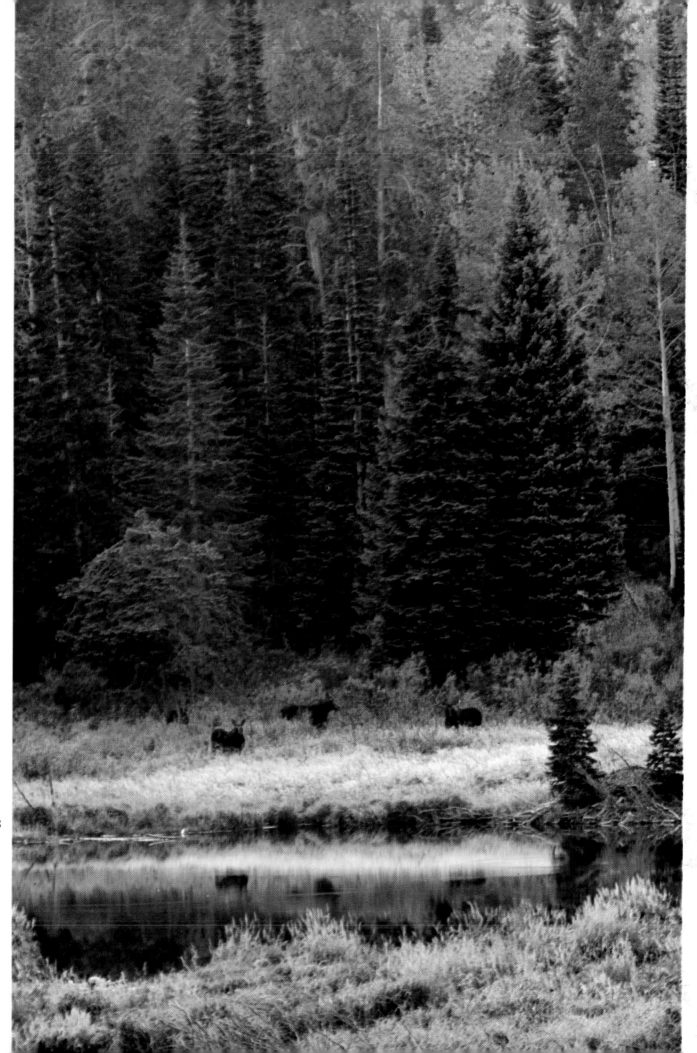

68

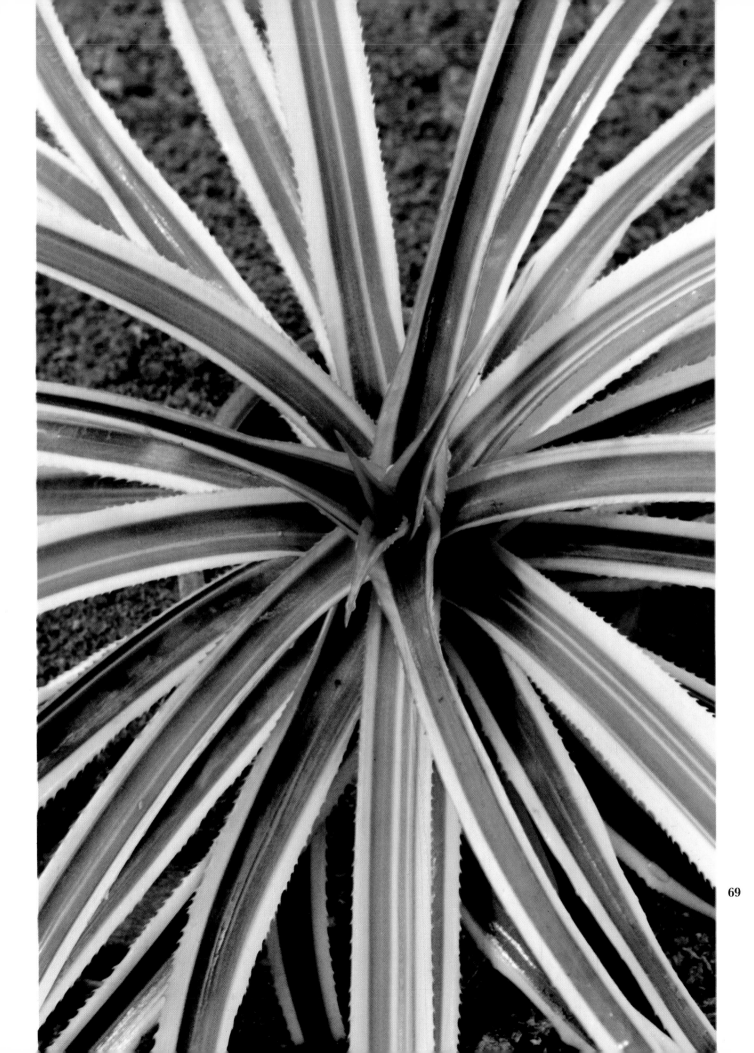

69

IV

PATTERNS AND TEXTURES

When you get down on your knees outdoors, or lie flat on the ground in a meadow, you discover a whole new world, in which tiny plants become as big as trees and insects look like huge unknown animals with startling shapes and colors. You can do this anywhere. You don't have to take trips to exotic landscapes in Africa or South America to take interesting pictures of nature. The important thing is not so much what you see and take, as how you see and take it. The patterns and textures of nature open up whole new avenues of exploration.

What you may need in such situations are a few close-up attachments such as extension tubes, which will allow you to photograph right inside a plant or flower. Sometimes, in order to get maximum depth of field at very close quarters, I have to close the diaphragm down to a minimum, which means that a cable release and sturdy tripod may have to be used to avoid vibration of the camera during a long exposure.

But there are very many wonderful patterns and textures in nature that can be photographed without any elaborate equipment at all. A great many of my photographs have been made with nothing more than a hand-held range-finder camera with a 50-mm. lens. Patterns made by footprints in the sand or leaves floating on the water, often unforgettably lovely and exciting, can be photographed with the simplest of snapshot cameras. More versatile equipment naturally makes it possible to photograph a greater variety of subjects in difficult conditions, but, in the end, it is imagination plus the ability to see and appreciate the beauty in the world around us that makes good pictures.

99

Owning an expensive camera and a lot of lenses has never made a great photographer of anyone. You have to learn to really look at things in a new way, to see things as a photographer sees them, to develop what is known as the "photographer's eye." In time you begin unconsciously to recognize how things will look when photographed within a certain format, in a particular light, from one distance or another, with the lens you have available. Reflex cameras and light meters can make some of this easier for you, but interest, understanding, and your own sensitivity to nature are the things that make it possible to find unusual pictures in ordinary situations.

After years of taking photographs for a living and as a hobby, I find that, wherever I go, I see things as the camera sees them, sometimes with "telephoto eyes," sometimes with "wide-angle eyes," or as they will look in color or in black-and-white. I think this happens to every photographer: he begins to see the world in terms of the choices that he knows are available to him, and in time he develops a faculty of instant recognition.

Once you are bitten by the idea of finding unusual subjects, everything you look at has a way of falling into a pattern of shape, color, or texture that can be photographed in a variety of ways, with results that may sometimes come out looking as abstract as a modern painting. You just have to be completely receptive to nature, uninhibited, and ready for new ideas. Never should anyone be afraid to experiment and to keep on experimenting with new situations.

NOTES ON PLATES 69–95

69. In order to show the symmetrical pattern of this bromeliad, I shot straight down with the help of a tripod and closed the diaphragm of my camera down to a minimum to get as much depth of field as possible.

70. A study of form and pattern. Luna moths come out at night; during the day they stay hidden, safe from preying birds. This one was poised on a twig of a chokecherry tree beside a pond at about eleven o'clock one morning. I deliberately underexposed the picture in order to show the moth as it is usually seen, after dark.

71, 72, 73. The results of three experiments using a 500-mm. mirror lens. The beautiful pictorial effects produced convinced me that, used at the right time and with the right

subject, this lens would convey just the ideas I wanted to express, reducing objects into semi-abstract images. The lens has only one aperture—f/8—so exposures could be varied only by timing. The picture in Plate 71 was taken about four o'clock one August afternoon. In the background is sunlight, very much diffused, coming through the windows of a dilapidated fishing shack. The seagull in Plate 72 was sitting at the end of a dock in the glaring afternoon sun. Diffused reflections from the water behind it, bouncing off the mirrors of the lens, created a repetitious abstract pattern in the background and distorted the faint outlines of a man in a small motorboat at the right. The peculiarity of this lens is even more evident in Plate 73, which shows an abstract pattern of light reflected from ripples in the water.

74. Although the long shadow creates an illusion of late-afternoon sun, this lonely little chickweed plant was photographed on an August morning at about eleven o'clock. Chickweed usually grows in a nondescript mass, but this single plant was growing out of the side of a sand dune at a diagonal, to catch the sun. The texture of the sand is an important element in the picture.

75. The silvery, fleshy-leaved plant known as dusty miller grows in attractive patterns along sand dunes. This specimen was taken with a 55-mm. lens, shooting straight down. An obliging ladybug sitting in the middle of one cluster of leaves adds a central spot of color.

76. Long, low rays of evening sun created this sculptural pattern of shadows in the sand. If you keep your eyes open when you are outdoors, the most insignificant things can have great potentialities, provided you are able to recognize them. On a dull day, without the sun to mold the outlines of the pattern, this patch of sand would have been totally uninteresting.

77. An interesting comparison of pattern and texture in two otherwise unrelated objects may be made between Plate 76 and this photograph of a langur. The choice of position, lighting, and company was all his, rather than mine, so I had to use a 400-mm. lens to bring us closer together. The long lens brought every fine line of the monkey's bushy eyebrows and shaggy head into sharp focus and diffused unimportant background and foreground details into a soft haze.

78–82. Five subjects found in the rain forests of Surinam, near the Mapana Creek. Plate 78 shows a katydid perched on a leaf. In Plate 79 a winged seed pod has fallen among the leaves on the forest floor. A white fungus covers the twigs in Plate 80, and Plate 81 is a gill fungus, Lepiota. The brilliant blue fragments in Plate 82 are the wings of an Agamemnon Morpho butterfly. It was necessary to use a stop watch to time the unusually long exposures necessary in the dim light of this tropical forest.

83. A close-up of geranium leaves taken in the diffused soft light of a greenhouse.

84. Seastars left nestling among the rocks by a fast-receding tide. A hand-held camera with 50-mm. lens was used in direct sunlight. The tide had left everything glistening with just enough water to provide some attractive reflections.

85. Red- and blue-leaved caladiums growing in a greenhouse. The plants were lined up on the floor, and the picture was taken with a 35-mm. lens, shooting straight downward to get the striking over-all effect of pattern and color.

86 and 87. Unusual seastars in the shallow tide pools on James Island in the Galápagos. They were photographed through about two inches of water, with a 50-mm. lens and a polarizing filter to penetrate the surface reflections. In Plate 86 there are actually two creatures; the shiny speckled mass in the lower right corner of the frame, blending almost invisibly with the rock and slightly overlapping the circular white seastar, is one of its relatives turned upside down.

88. A pink succulent plant found among the rocks in the Blue Ridge Mountains. Dry autumn weather had taken most of the color from the lichens. There was little sun, and the lack of strong highlights made it possible to get all the detail of the dark, rough texture of the rocks.

89. These prickly seed pods belong to the plane trees in the Tuileries Gardens and were photographed against a hazy sun while I was seeing Paris anew through a 500-mm. mirror lens.

90. Details of nature sometimes present the impression of an abstract painting. This intricate, undulating pattern, photographed with a 50-mm. lens, was made by fungus growing on a fallen tree.

91. A floating leaf photographed in the Japanese Garden in the Golden Gate Park in San Francisco. The shadows of overhanging branches created a pattern much like that of a Chinese or Japanese print.

92. Millions of tiny dewdrops on the grass early one foggy September morning. I used a

55-mm. macro lens with the aperture closed way down to get maximum sharpness.

93. Golden leaves at the bottom of a small stream provided some warm color for this pattern of reflections.

94. Two beady eyes and a great smiling mouth. Actually this is a minuscule section of a moth orchid, an *Oncidium kramerianum,* taken in a greenhouse with a 135-mm. lens attached to long extension tubes. The aperture was set at f/16 for a time exposure of eight or nine seconds. These orchids are difficult to photograph because their very delicate stems cause them to vibrate, even when supported by wire.

95. Two more beady eyes and another smiling mouth. The bullfrog was easily startled, so I used a telephoto lens with extension rings and, starting from a good distance away, inched slowly toward him. Luckily he kept right on blinking and smiling, instead of disappearing just at the crucial moment as I expected him to do.

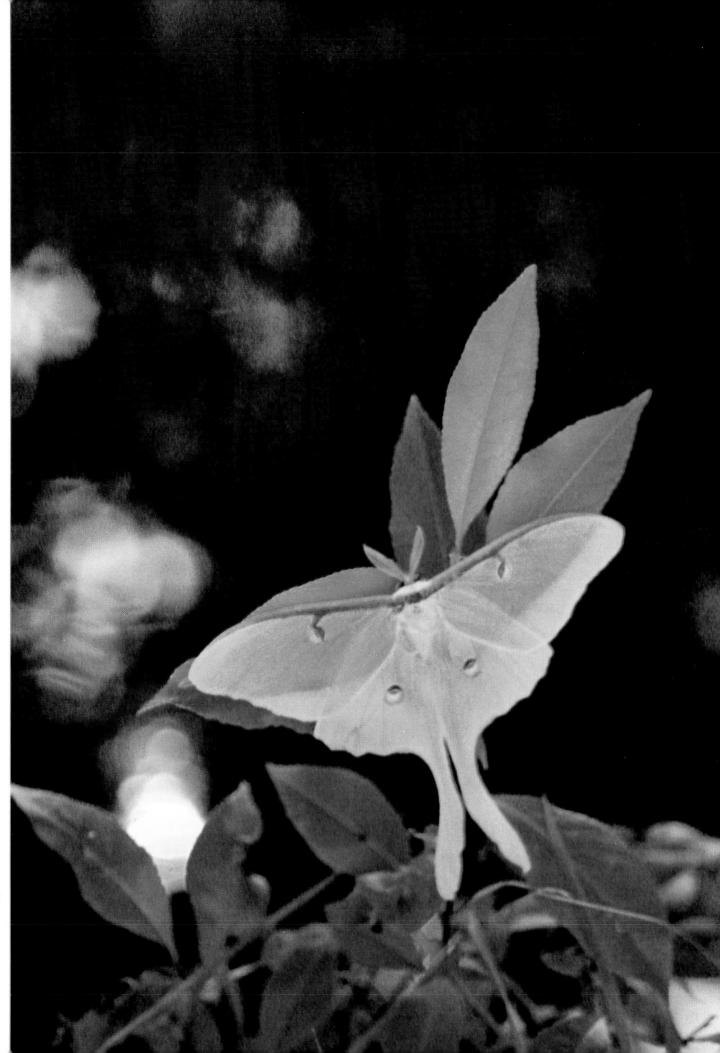

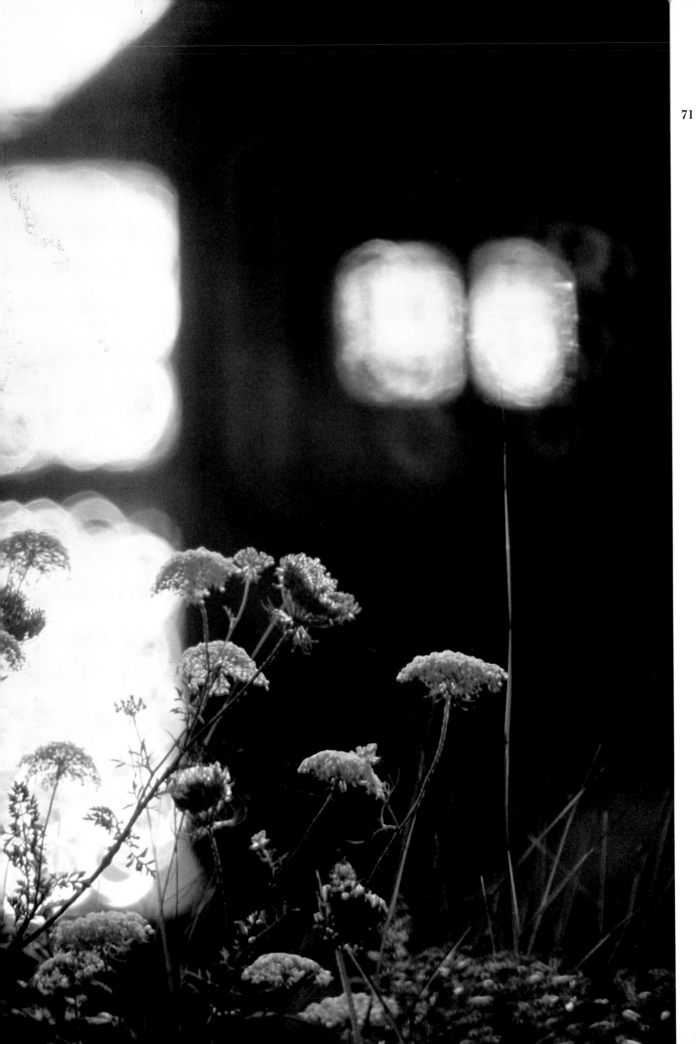

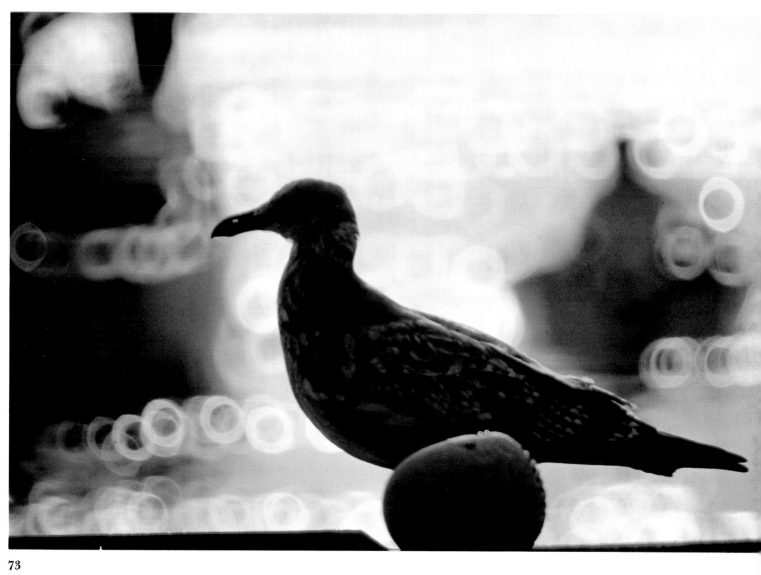

73

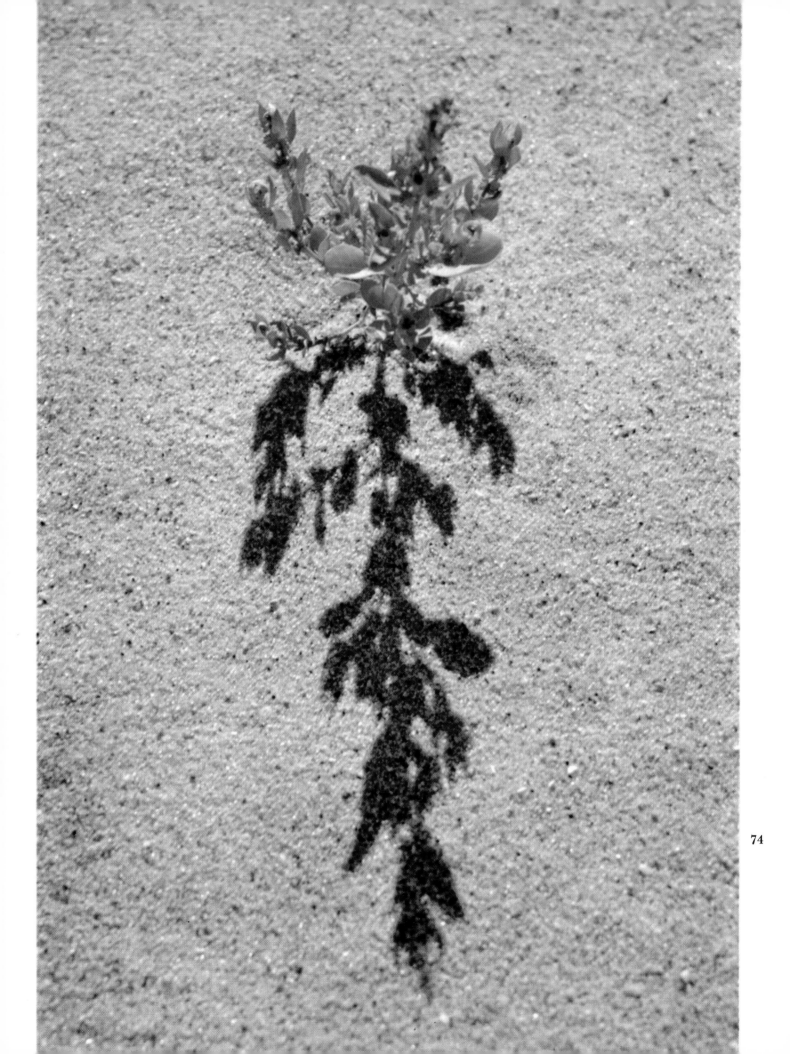

74

75

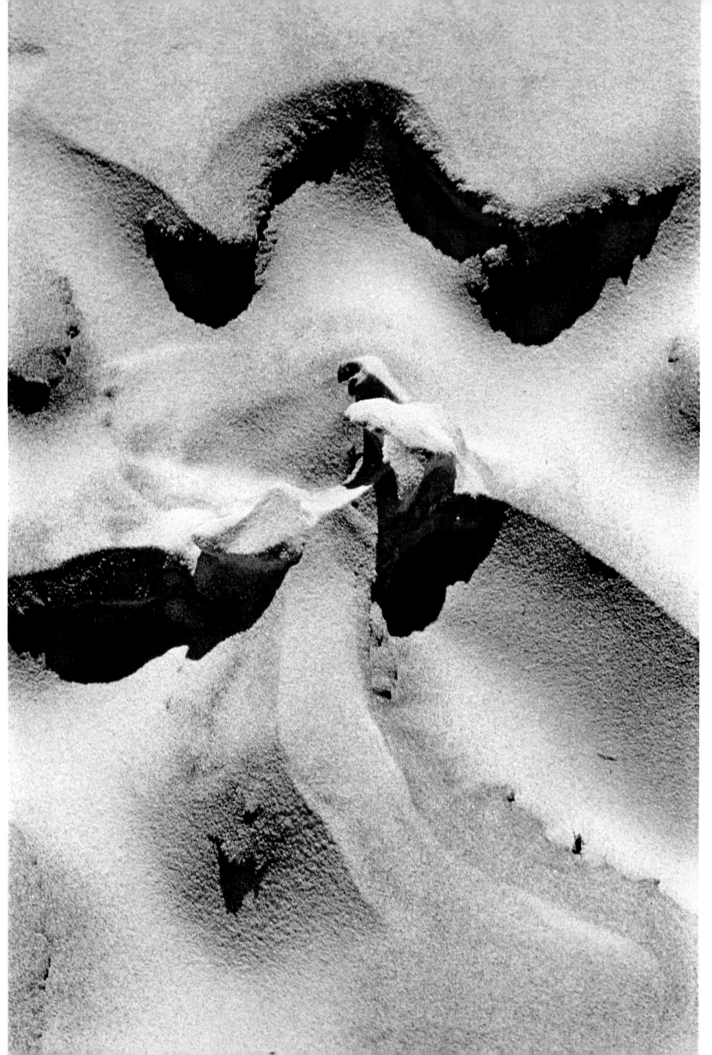

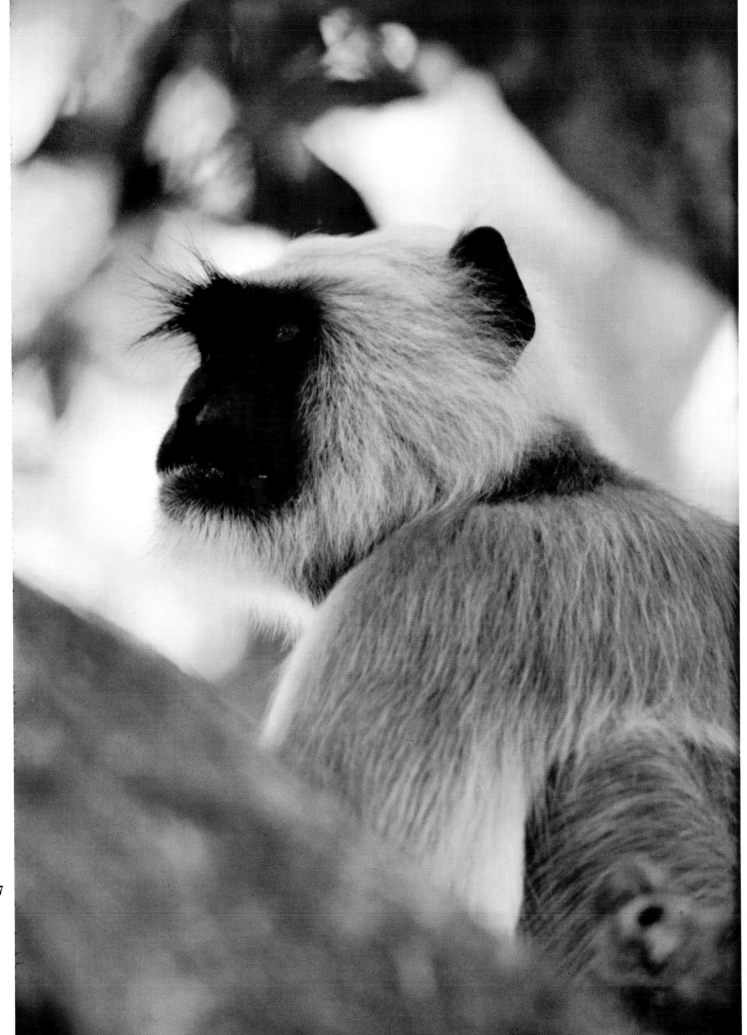

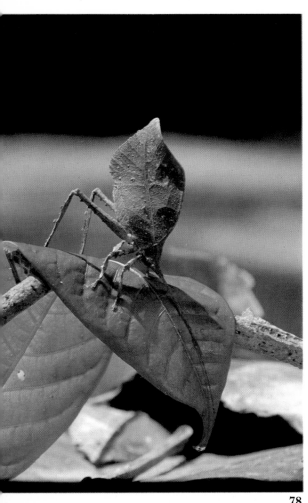

78 79

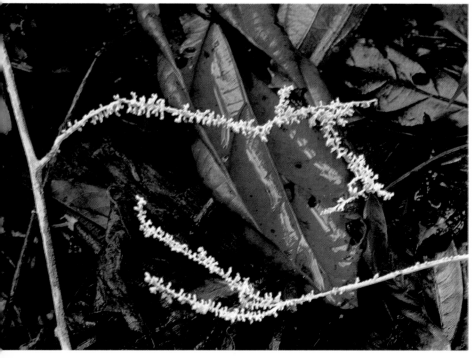

80

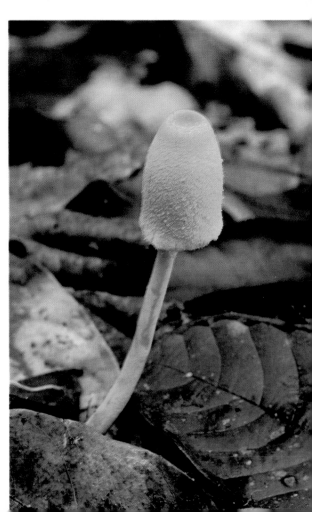

81

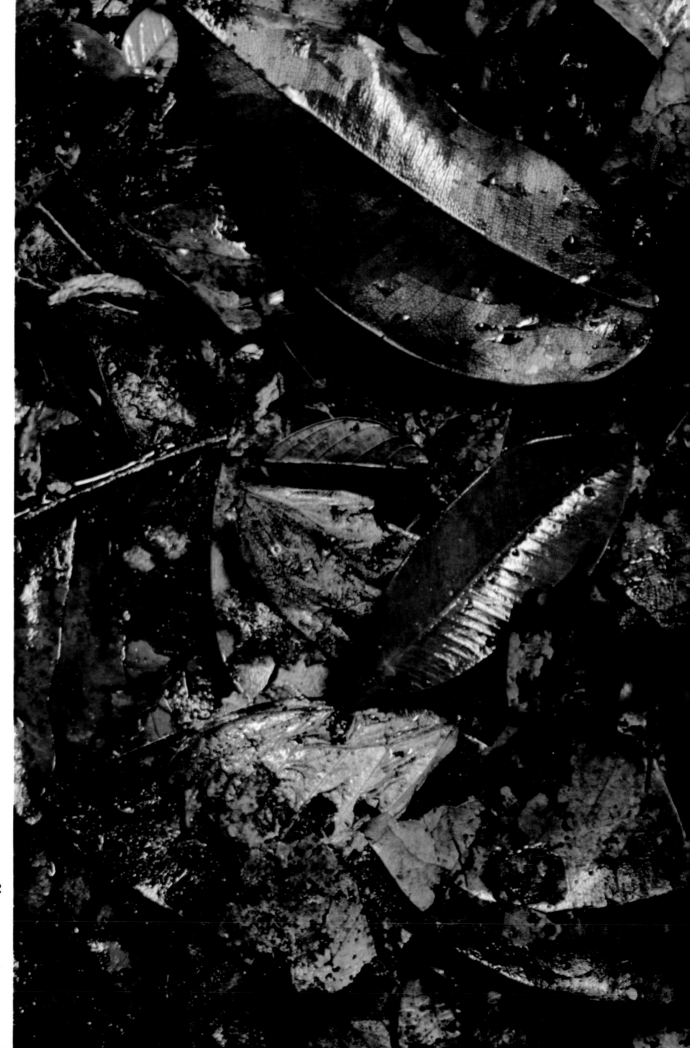

82

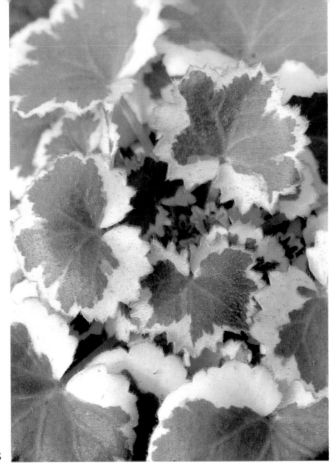

83

84

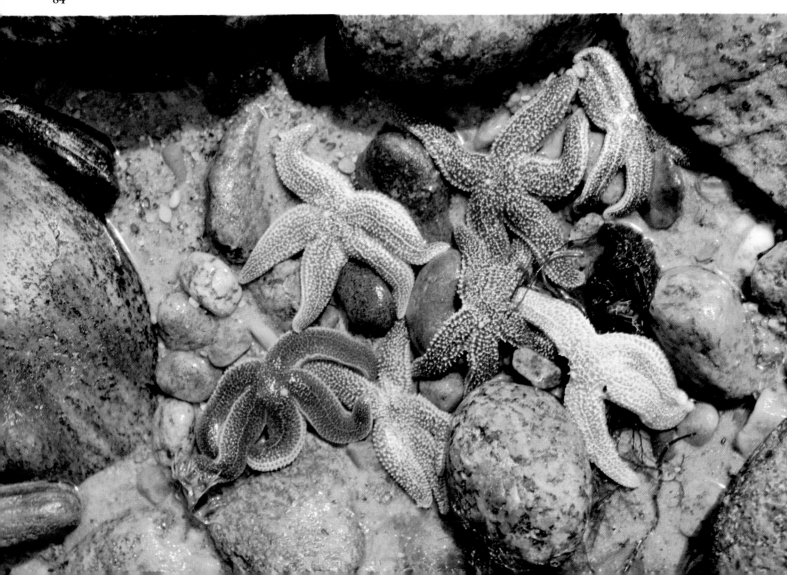

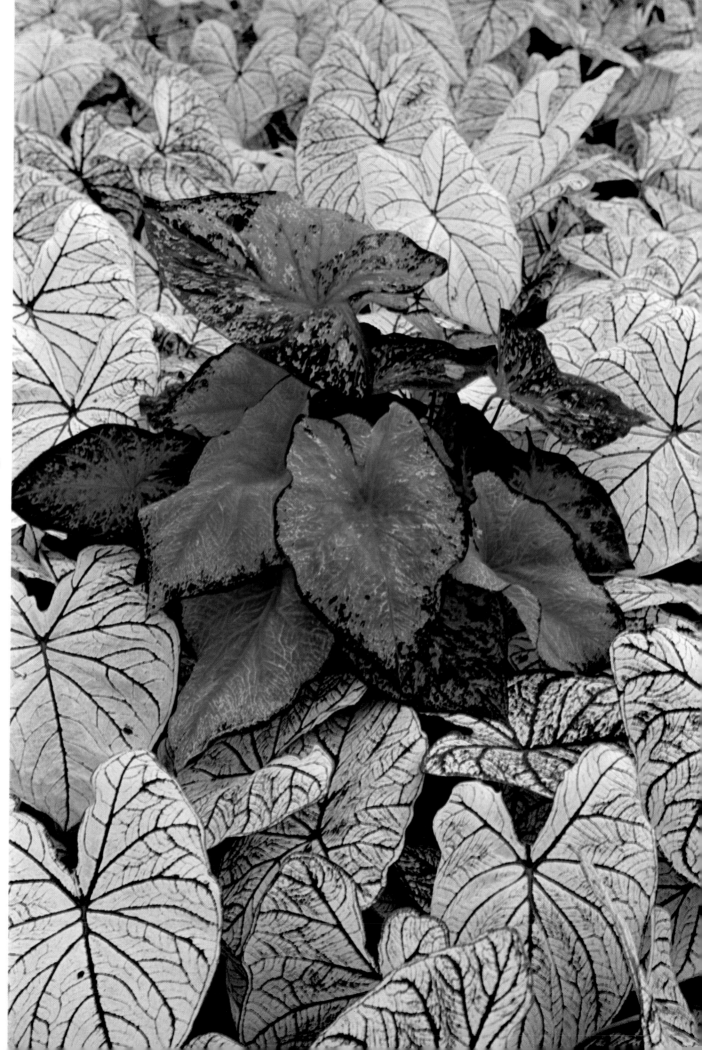

85

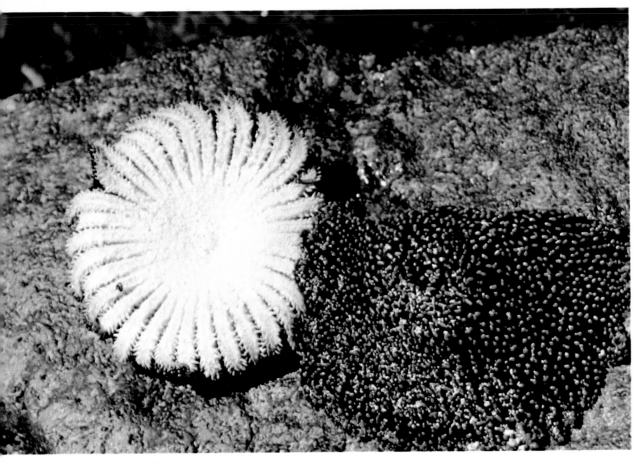

86

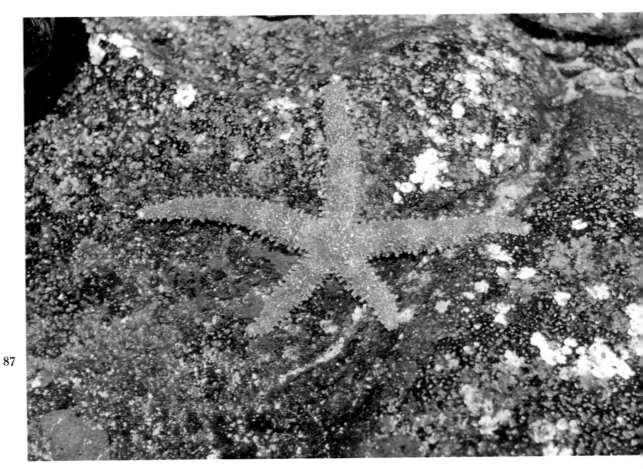

87

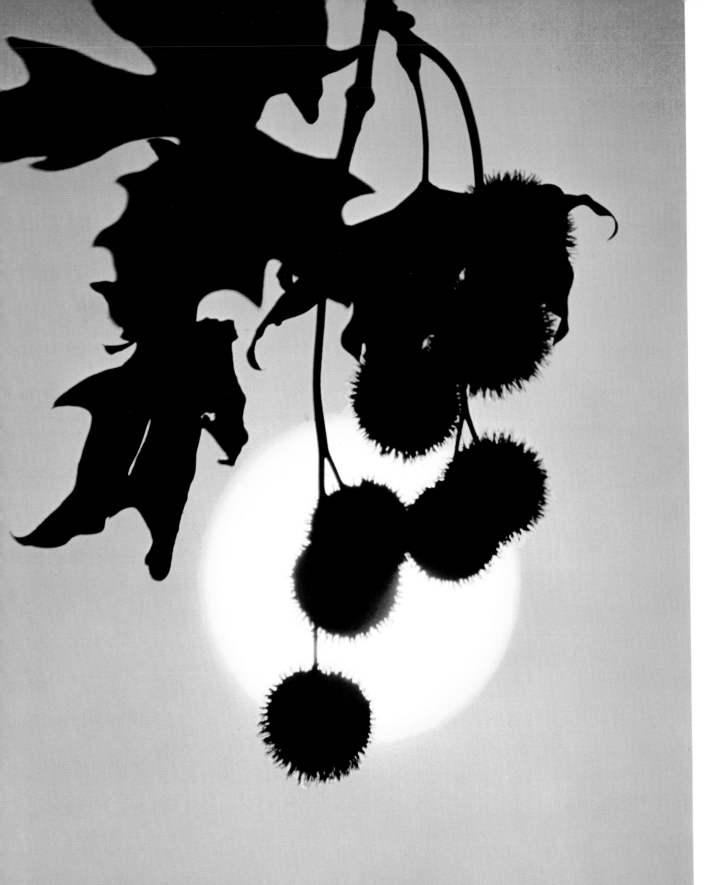

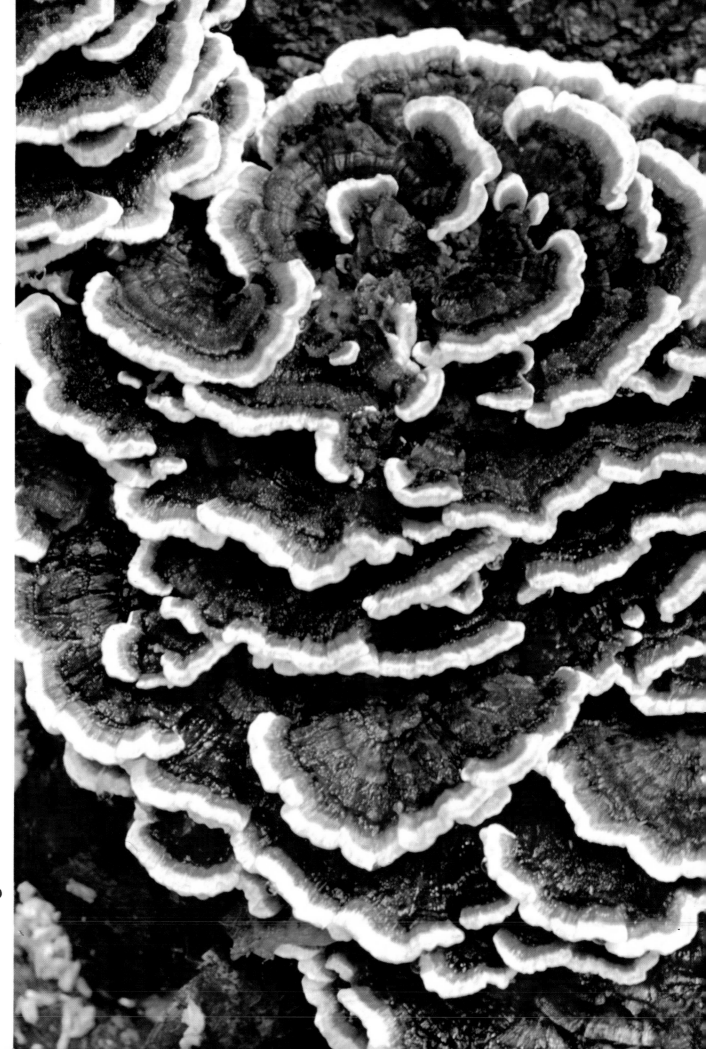

90

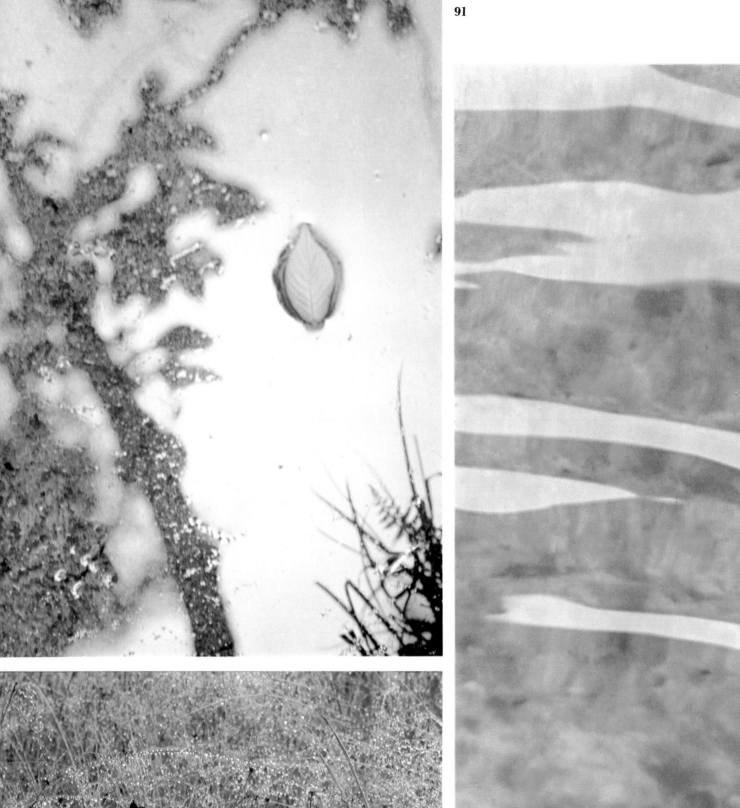

91

92

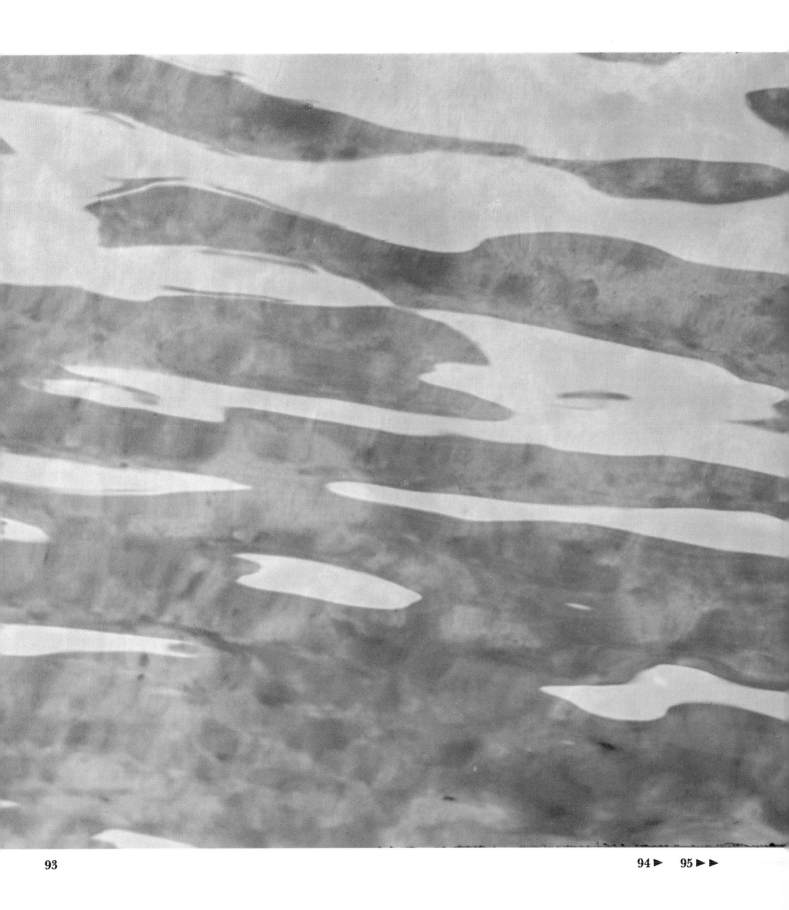

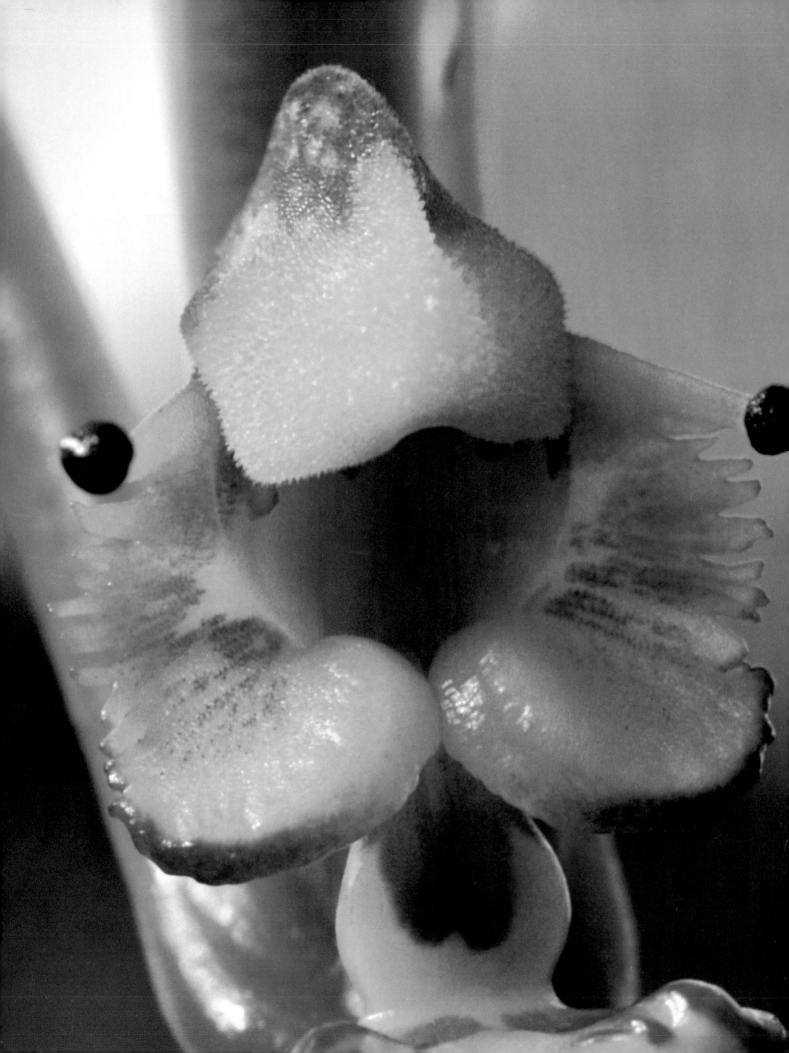

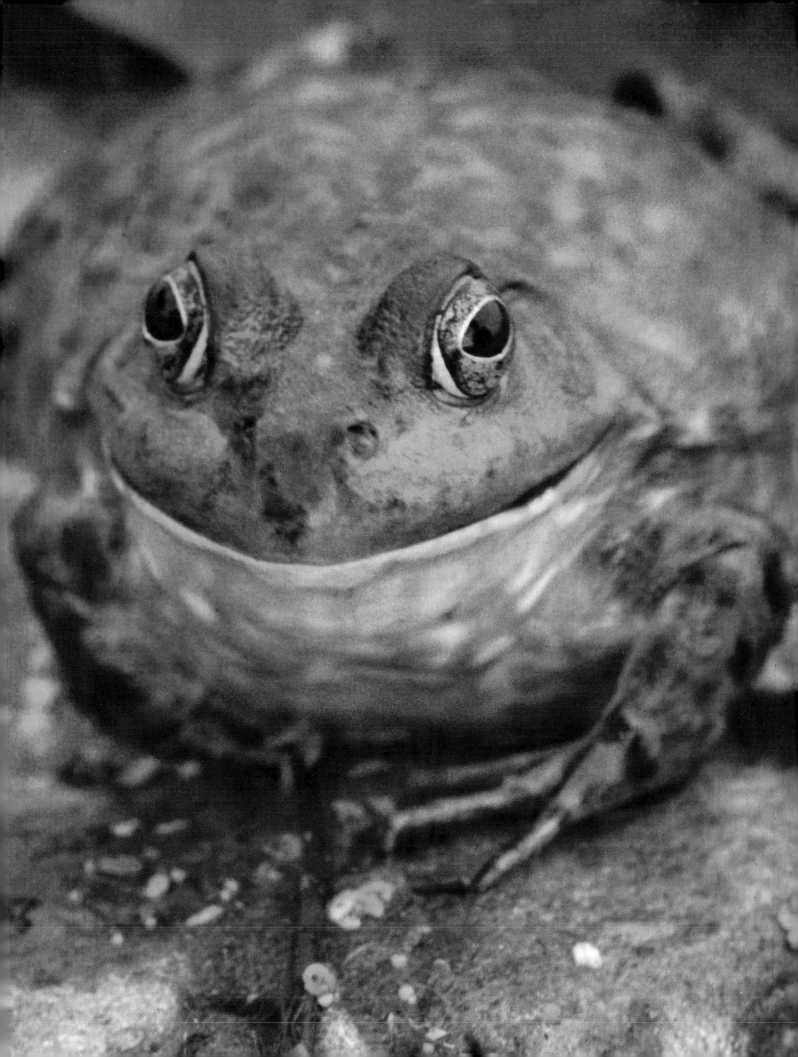

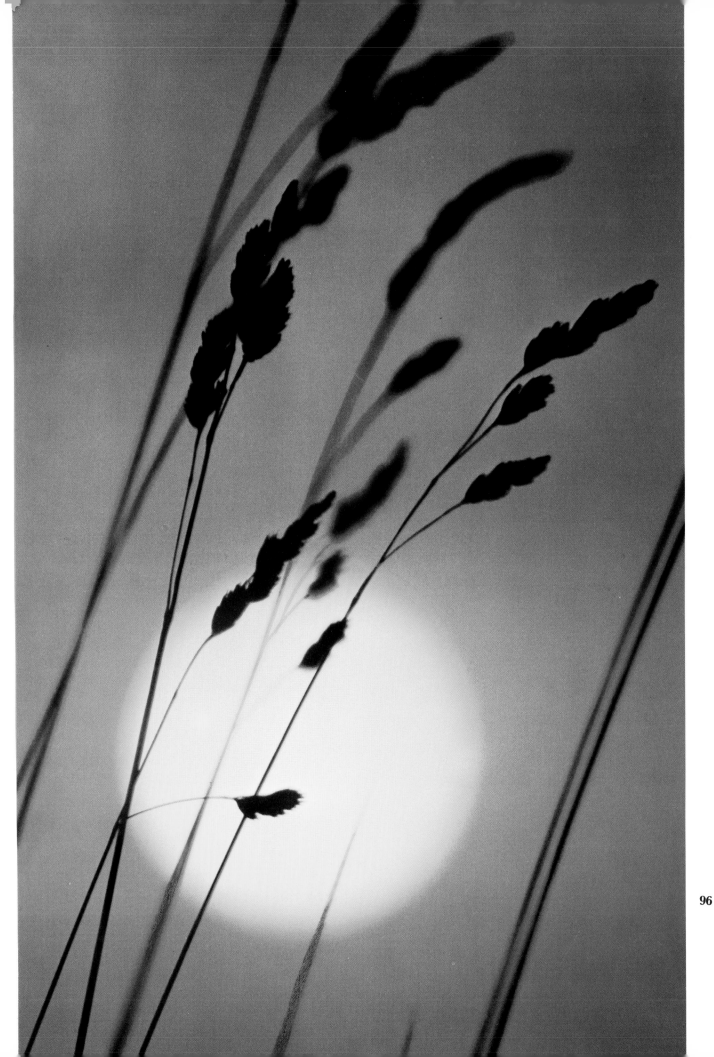

V

SPECIAL EFFECTS

Even after so many years as a photographer, I still wake up in the morning with a desire to try something entirely new. And today of course there are, technically, very many different things that one can do by experimenting with new lenses, filters, and various color films, in addition to using one's ingenuity to reinterpret and rediscover nature in the light of one's own ideas.

By manipulating equipment experimentally, often by completely defying all the standard rules and instructions, using films and lenses in ways that they were not designed to be used, I have been able to achieve striking pictorial results. There is a danger in all this of developing tricks that lead in a direction one doesn't want to go in. But without experimenting one cannot tell. And there should not be any rule that the camera cannot be used in any way one wants, provided the end result is interesting and the special effect represents a definite point of view.

Merely by changing focus or my vantage point, I have produced many different impressions of the same subject, pictures that were entirely different in mood and perspective, even though they were taken in the same place and at the same time. Some of these have been deliberate, as in Plates 107 to 112. Others, I must admit, were happy accidents, complete surprises that came about when I was experimenting with films and equipment. Although infrared color film, for instance, was originally intended for military use rather than creative photography, I have used it to make dramatically colorful interpretations of landscapes. One of these is shown in Plate 98.

Prism lenses are full of surprises. I never get tired of playing with them because there is no end to the variety of patterns that can be created, as in Plate 113.

I have also used indoor film outdoors (Plates 67 and 68), and sometimes I have drastically underexposed outdoor film, both with the object of changing the mood of a scene. In this manner broad-daylight shots can take on the light of evening, or an air of mystery that ordinary use of film would not produce. Wonderful poetic effects are also possible with telephoto lenses, as distance is foreshortened and foreground objects are thrown into a soft, romantic haze. Color filters can also change things completely.

One big point that is often overlooked by amateurs is that color photographs do not have to be taken in bright daylight. Many creative photographers prefer the light and shadows of the very early morning, or the redder hue thrown by the last rays of sun in the evening, or they look for subtle effects on a rainy or overcast day. Fast color films have broadened the scope of a photographer immeasurably.

Yet another technique is purposely to blur certain elements of a photograph, as in Plate 116. The feeling of motion, for instance, can often be better achieved through a blurred image than through a shot of a bird in flight which freezes motion rather than extending it.

Nature is not an abstraction; it is very real and visible; but just as no two grass blades are alike, no two people see things in exactly the same way, and the photographer with an open mind and a willingness to experiment can find ways to state impressions of nature that are entirely his own.

NOTES ON PLATES 96–118

96. A brilliant August sunset, photographed with a long telephoto lens focused on the foreground grasses and with a light red filter to enhance the redness of the sky.

97. While I was photographing roadside flowers with a 50-mm. lens, this horse came into view. I quickly changed to a 200-mm. lens and focused on the animal, letting the flowers blur into a soft frame around it.

98. This is not some strange planetary landscape but a view on Martha's Vineyard, photographed with infrared Ektachrome film

and with a #12 yellow filter plus a polarizing filter to create the vivid color contrasts. The film registers green as red, and the blue sky has become dark gray—almost black. At the time I took this picture, infrared color film was very unstable, and I never knew quite what I would get with it. In general, I have found that a clear day after a rain is the best for bringing out the bright color effects possible with this film.

99, 100, 101. Three pictures of autumn foliage taken with infrared color film, but without any filters.

102. Pink and blue effects strikingly similar to those in Plates 99, 100, and 101 were produced by photographing a pond early in the morning, just before sunrise, with ordinary color film and a light blue filter.

103 and 104. A quite different mood from that of Plates 99–101 is expressed in these two pictures taken with infrared color film on an overcast day. I underexposed them a little and did not use a filter. The hemlock branch in Plate 104 overhangs a river, and the background pattern is formed by the reflection of the trees on the opposite bank.

105 and 106. A change in the weather or in the time of day can make a great deal of difference in the mood conveyed by two pictures of the same place. These photographs were taken near Svolvaer in the Lofoten Islands, above the Arctic Circle in Norway. Plate 105 was photographed at about ten o'clock in the morning, in full sunshine when a few clouds were moving across the sky. Plate 106 was done from a slightly different vantage point, in the evening, under a partly overcast sky. This time I was shooting against the light source, so that most of the scene is in deep shadow, dramatically silhouetted against the sky and the water. I also used a longer lens, bringing the mountains closer.

107–112. Variations on a theme. Six photographs using the same simple, ordinary subject in nature: Queen Anne's lace growing beside the water. No special equipment was needed to produce these quite different effects; it was done just by changing the angle of the camera and the focus. The rest was the work of patience and of nature. As you can see, some of the pictures were made when the blossoms were not entirely open, and others when they were quite full. If you have ever spent much time watching sunsets you know how spectacularly different in color the sky can be, ranging from a cold, rainy blue to the brilliant orange of a hot, hazy day. Plates 108–112 were all shot toward the sun, but Plate 107 was photographed on a dark, stormy day when the flowers were blowing wildly in the wind.

113. Two prism lenses attached to the 50-mm. lens of my camera and complementing each other at a ninety-degree angle turned a small patch of cosmos into a delightful dream-like all-over pattern of blossoms. I find prism lenses a refreshing new way to witness the beauty of nature. One might be looking at the world through a kaleidoscope. The patterns are endless, and no two photographs are ever the same.

114. I was sitting in a small motorboat in the Everglades when I spotted this great white heron sitting on a tree root at the edge of the water. As the boat drew closer, the bird suddenly took wing, and I asked the guide to increase our speed so that I could follow the flight. We were moving fast enough to make the foliage in the background become a blurred pattern of light and shade. The heron's wings beating up and down created a ghostly translucent effect. At the moment I clicked the shutter, the boat and the bird were moving at approximately the same speed. Blurring the background this way conveys the actual experience of speed and motion much more effectively than freezing the action with a fast film and fast shutter speed. Similar effects of motion are possible from a fixed position if you move the camera in an arc to follow the subject's path of movement during an exposure. Another time the hours I spent crouching in the bottom of a small skiff resting in the shallow waters of a mangrove swamp rewarded me with pictures of a roseate spoonbill. I kept my 400-mm. lens trained on the bird, getting many pictures as it perched in repose on a mangrove root, but I wanted one of flight. As I sat there, hypnotized, my eyes became so tired that I could no longer see properly. I had to ask my guide to watch for me and let me know immediately if the spoonbill made any unusual moves. Meanwhile I kept my finger on the cable release. This is one of the rare instances when I was able to get only a single action photograph, and I was glad that it turned out so well, with just the impression of an ascending bird that I had envisioned.

115–117. These three pictures were taken in the Tuileries Gardens, with a 500-mm. lens. In Plate 116 I focused closely on the foreground twigs, so that the pelargoniums became a soft impressionist blur in the background. In photographing the trunks of the huge chestnut trees in Plate 117, I again

focused on the foreground. The long lens greatly foreshortened the distance between the trees, and in the background the soft haze in the atmosphere, so typical of Paris in autumn, was emphasized.

118. Peace and solitude by the sea, pleasantly remote from life in the city. My 400-mm. lens was wide open to catch the fading light as I photographed this seagull silhouetted against the sunset as it bade the world good night.

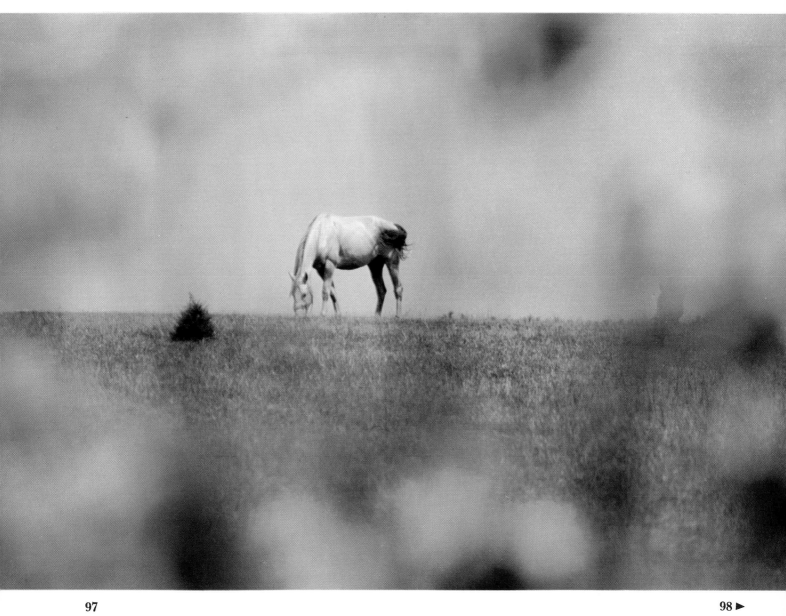

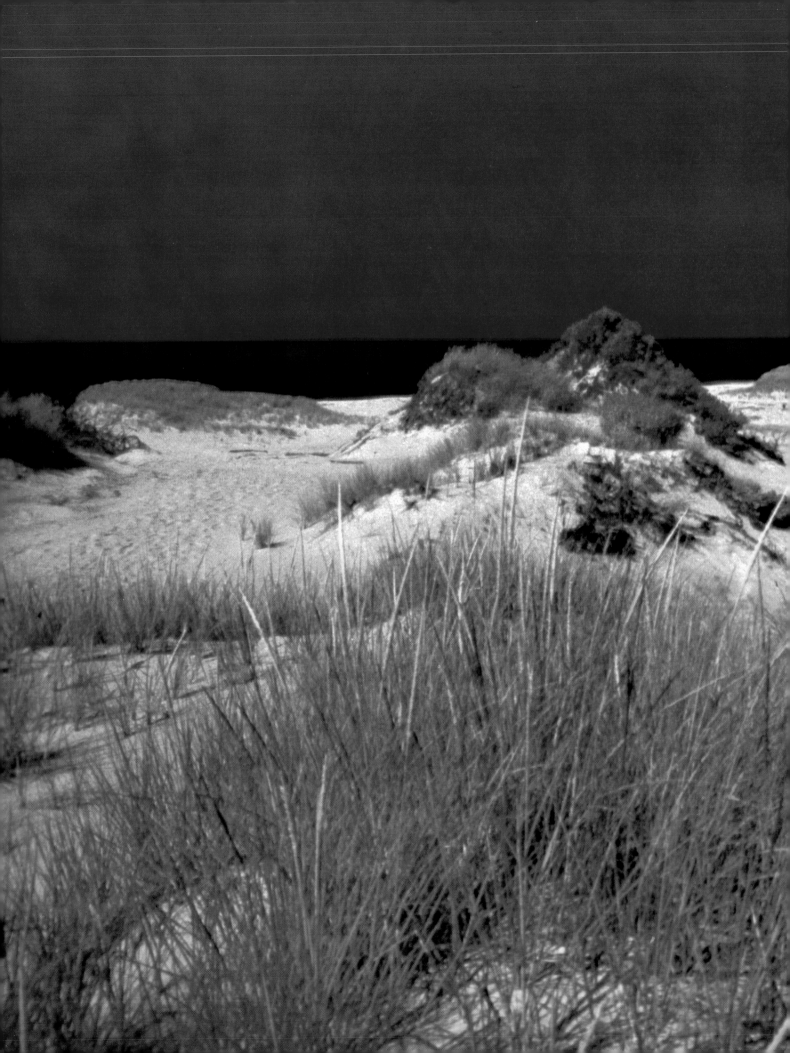

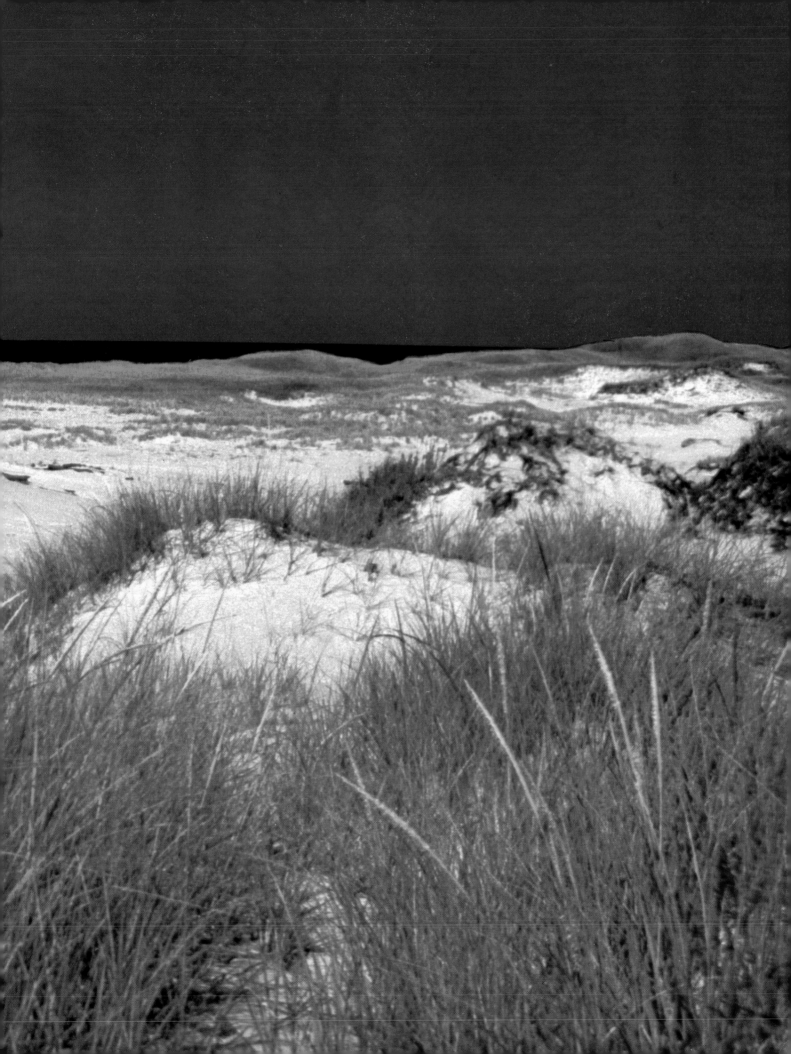

99　100

101

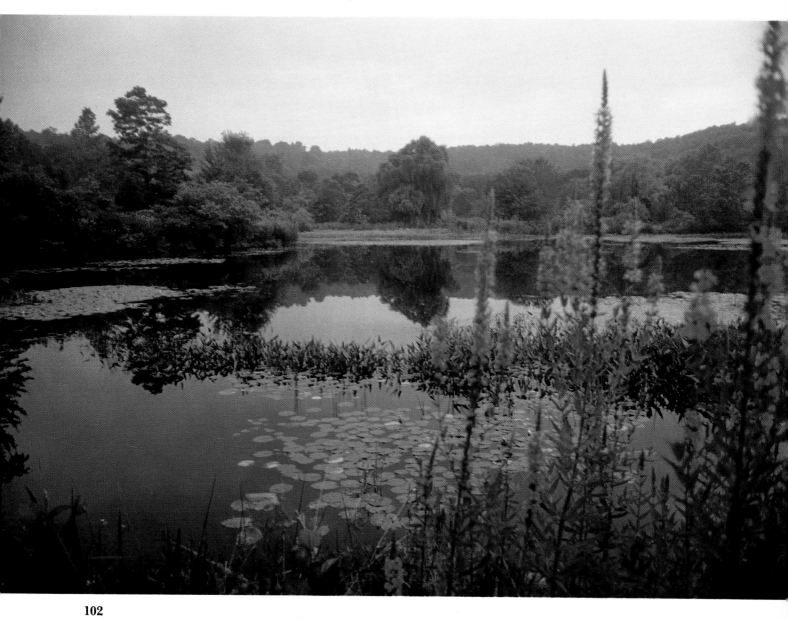

102

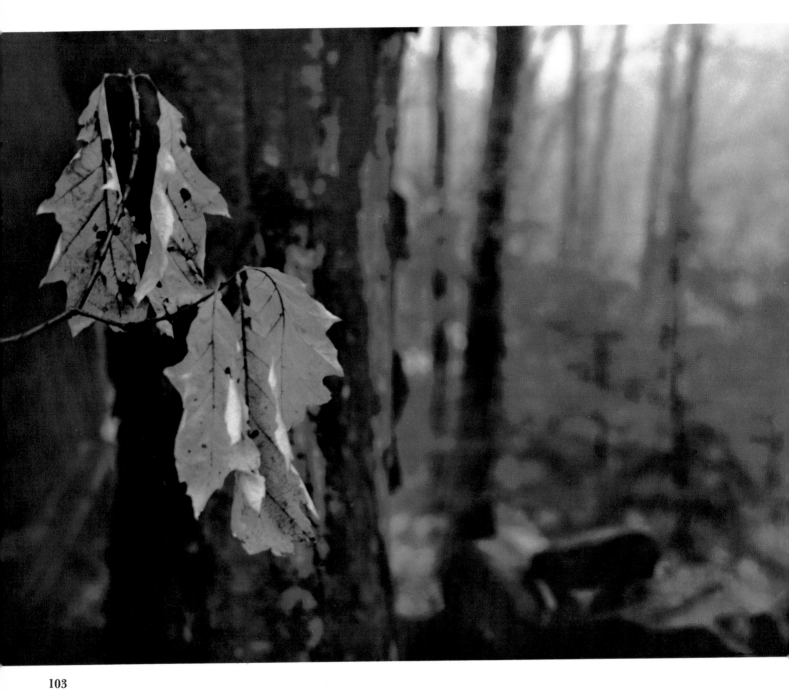

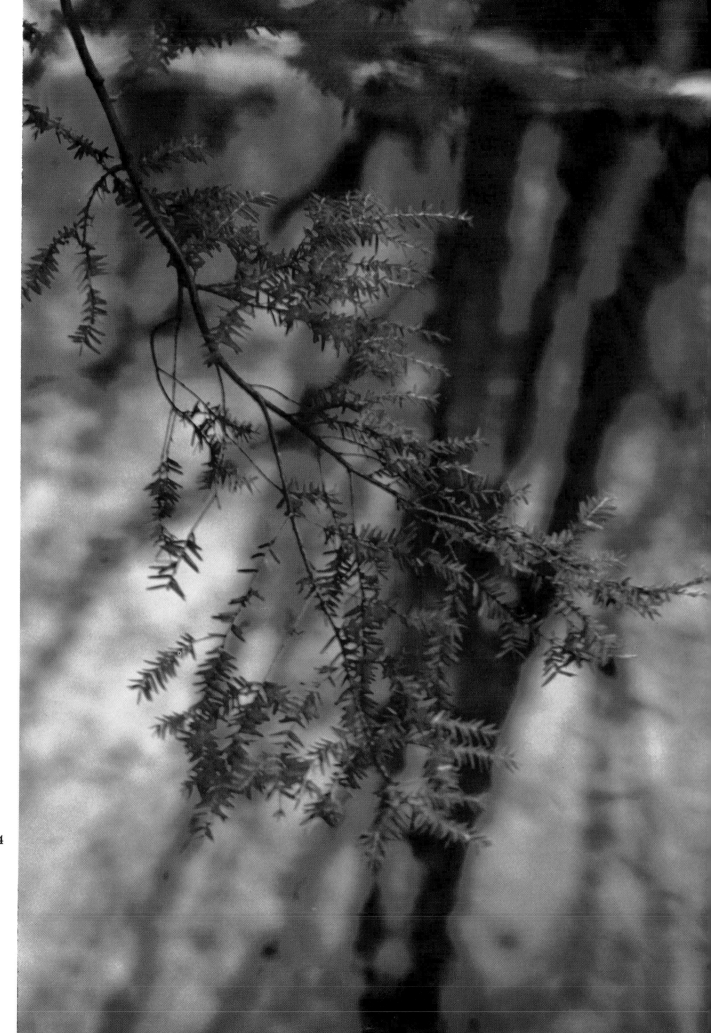

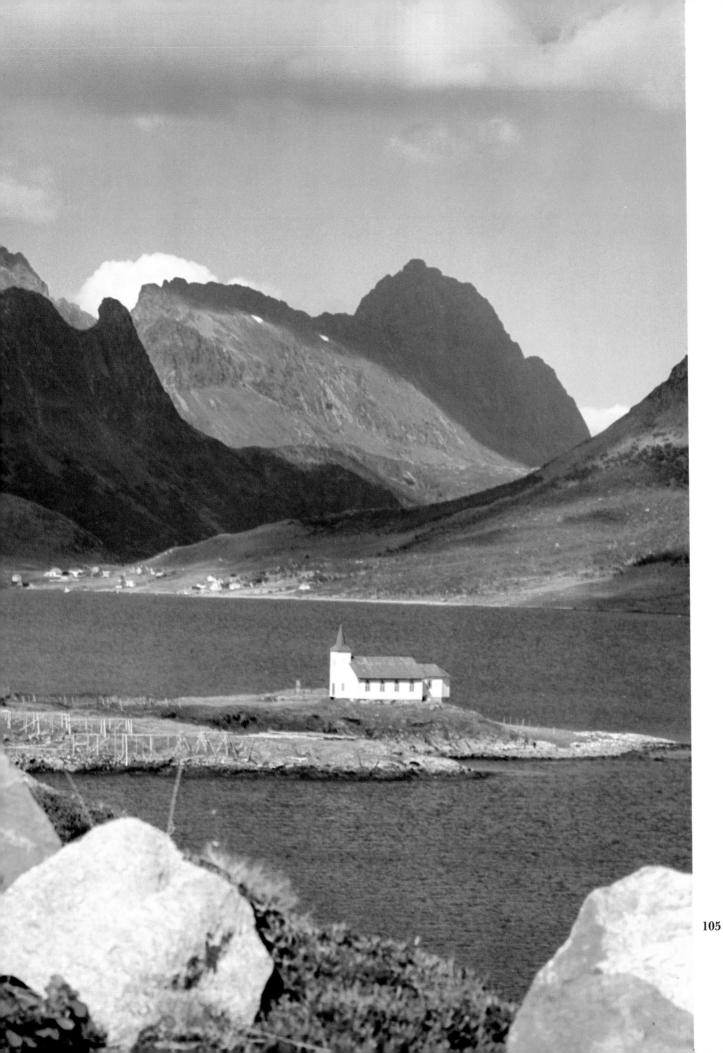

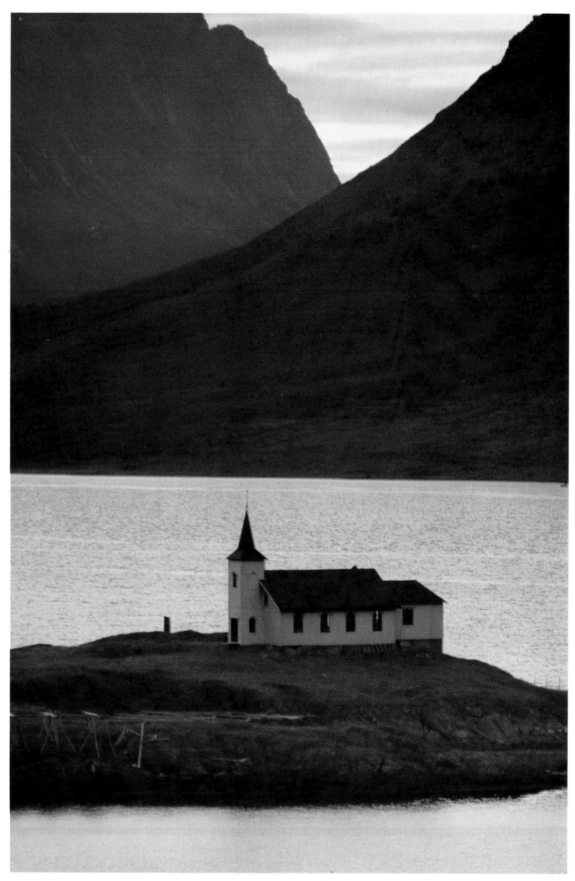

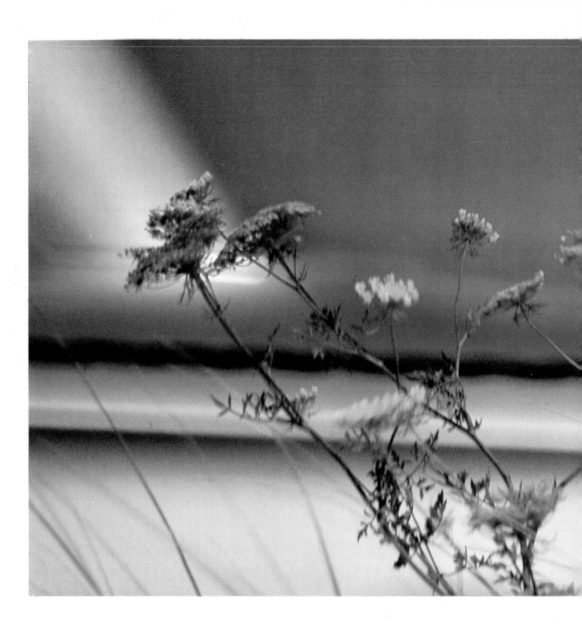

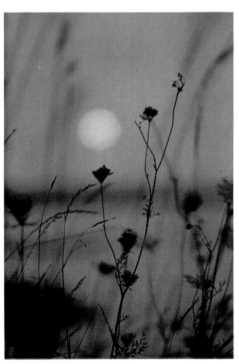
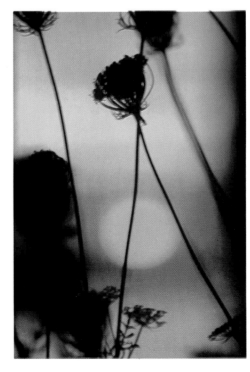
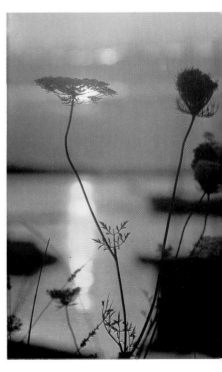

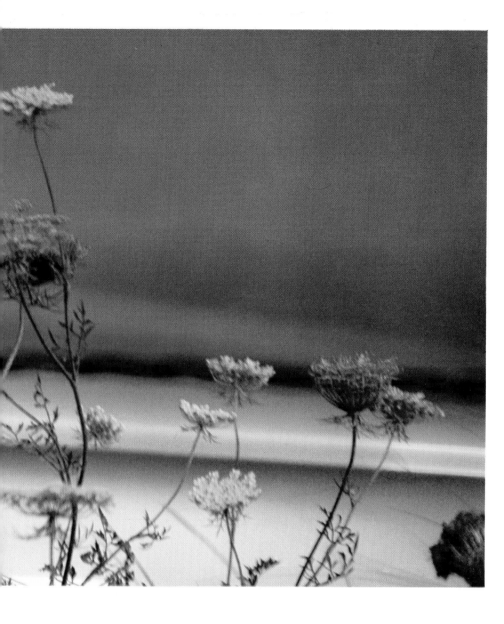

107 — 112

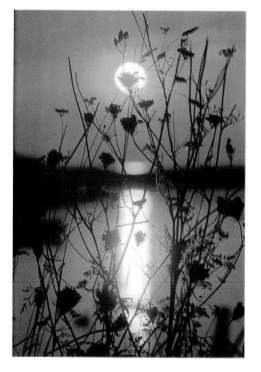

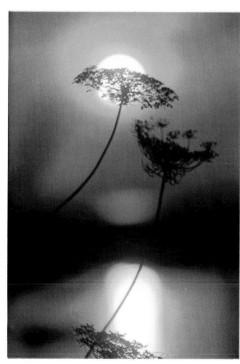

113 ▶

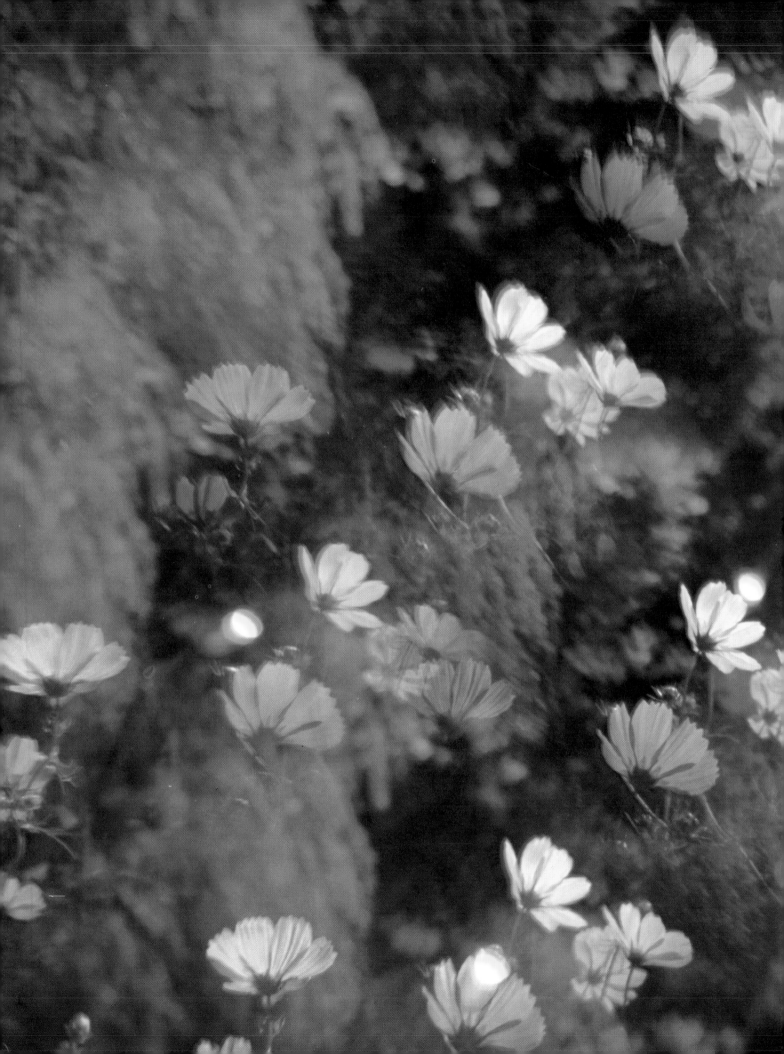

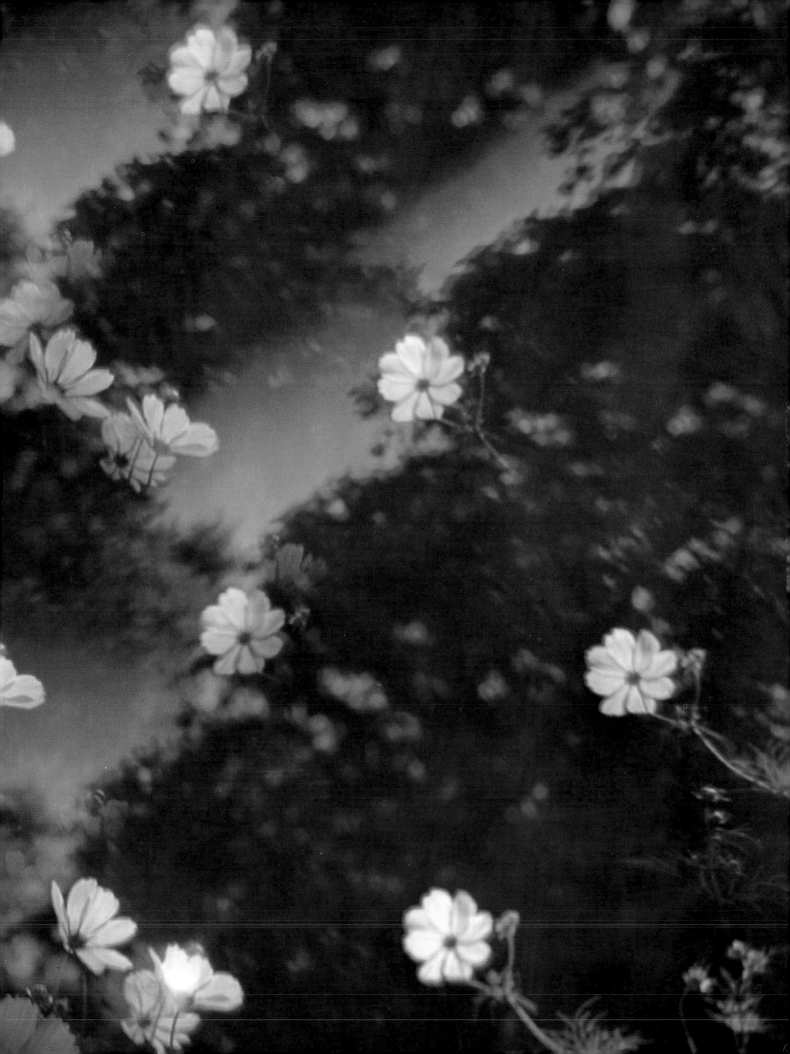

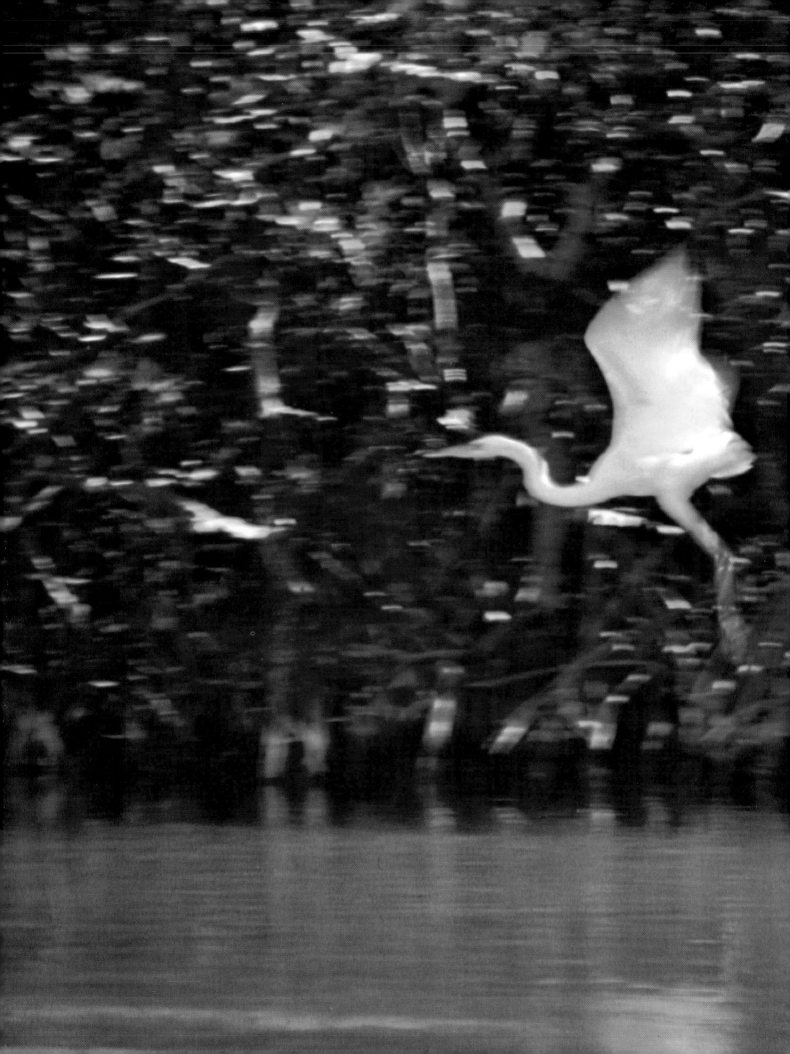

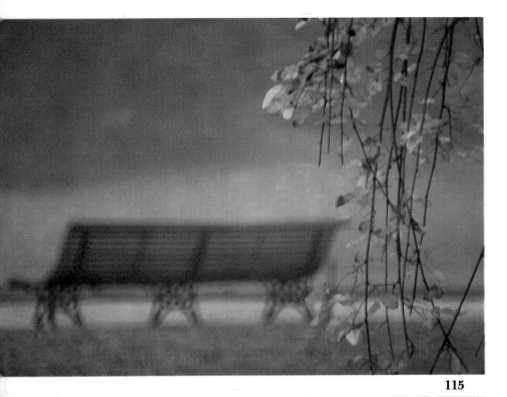

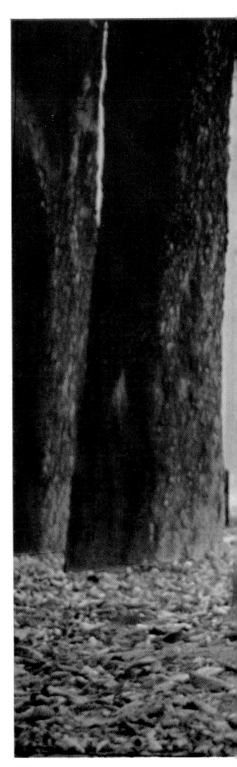

115

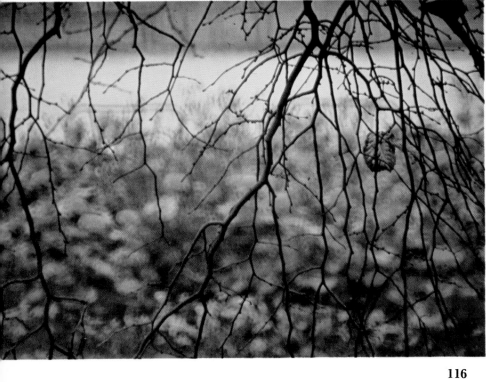

116

117

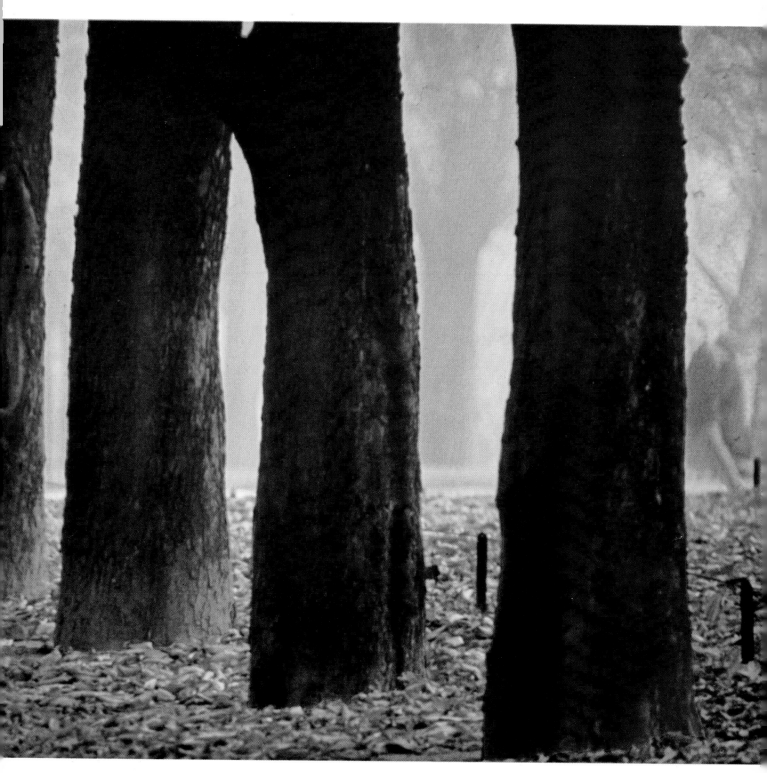

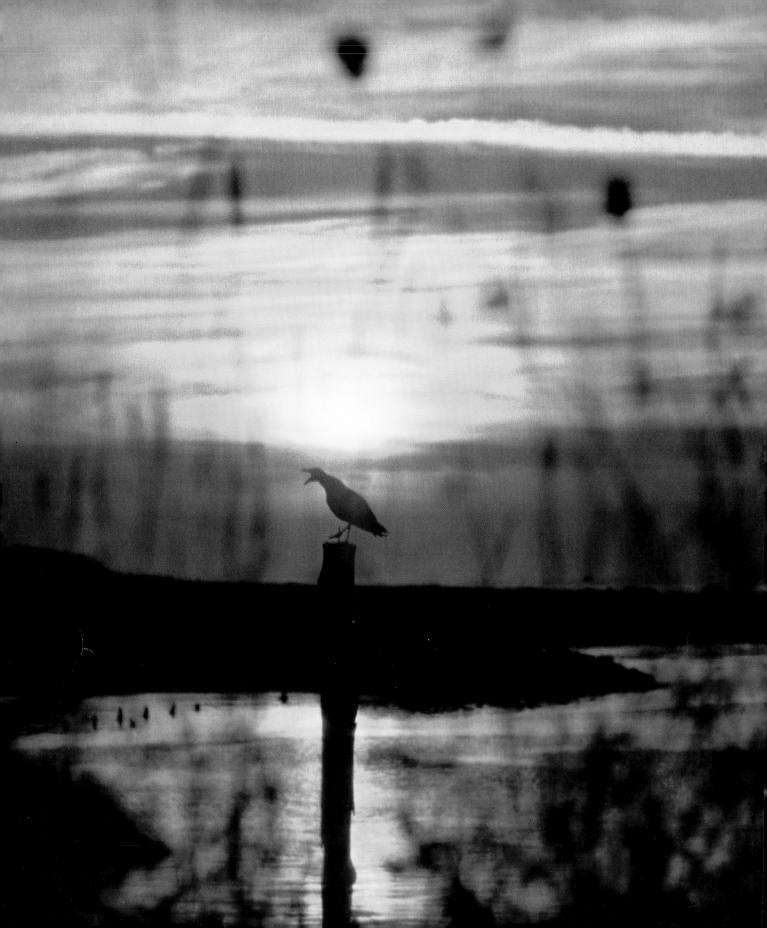